Lives of the Artists

ARTEMISIA GENTILESCHI

Jonathan Jones

Laurence King Publishing

LAURENCE KING

Published in 2020 by
Laurence King Publishing Ltd
361–373 City Road
London
EC1V 1 LR
United Kingdom
T + 44 (0)20 7841 6900
enquiries@laurenceking.com
www.laurenceking.com

Design © Laurence King Publishing
Text © 2020 Jonathan Jones

Jonathan Jones has asserted his right under the
Copyright, Designs and Patents Act 1988 to be identified
as the Author of this Work.

A catalogue record for this book is available
from the British Library.

ISBN: 978-1-78627-609-4

Printed in Italy

Laurence King Publishing is committed to ethical and
sustainable production. We are proud participants in
The Book Chain Project®
bookchainproject.com

**BOOK
CHAIN
PROJECT**

Cover illustration: Chris Gambrell

CONTENTS

Introduction

Artemisia Gentileschi was a contemporary of Shakespeare and Rembrandt, and a friend of Galileo – a great woman in an age we usually associate with great men. The emotional directness of her paintings helped to make European art more human and approachable in the great seventeenth-century democratization of culture known as the Baroque.

Behind that achievement, though, lies a brutal story. Artemisia grew up in Rome, a child prodigy trained by her artist father. She could paint like an expert by the time she was 17, but her reward for daring to be an artist was to be raped by a friend of her father's, another painter. Before the assault, he tore the brush and palette from her hands and told her not to 'paint so much'. When her father brought charges against him, Artemisia was tortured to test her reliability as a witness, but she remained insistent throughout, defiantly repeating, 'It is true, it is true'. The notoriety of the trial led to her departure from Rome. Artemisia survived this ordeal to become a successful artist with an international career. But her greatest achievement was to release her pain and anger in paintings that reveal her inmost feelings, an obvious example being *Judith and Holofernes*, in which two women are depicted slaughtering a man.

What kind of person could rock the male dominance of art and society so many centuries before modern feminism? Needless to say, an extraordinary one. Artemisia escaped a hopeless marriage to live independently as the head of a household. She also brought up

her daughter by herself, had at least one passionate love affair, and became celebrated for her articulacy, talent and beauty.

Artemisia was employed at two of Europe's great courts – working for the Medici in Florence, and for Charles I in London. She could certainly dress the part and perform music like a born courtier, but she had, in reality, been born on the wrong side of a dung-spattered alley. She grew up illiterate, in a tough part of Rome, among artists who acted like thugs and who were in and out of prison, and she never really lost her rough edge. She was as real as her paintings.

Toughest of the tough in the Roman art scene at the start of the 1600s was Michelangelo Merisi da Caravaggio, painter, murderer and friend of Artemisia's father. Caravaggio's sensational fusion of art and life enthralled her. She must have met this unforgettable character when she was a child, as he came in and out of her father's home workshop. She also studied his works in Rome's churches intently and became the most radical of his followers – the 'Caravaggisti' – building brilliantly on his revelation that art and life are doubles of each other. To say that this book is about her art as well as her life would be tautological. They are the same thing.

1

Susanna

In the summer of 1612, a proud father boasted about his child's achievements. The painter Orazio Gentileschi, writing from Rome, really lays it on in a letter to Christina of Lorraine, the Grand Duchess of Tuscany. He is, he claims, the parent of an artistic prodigy. Brilliant boys had achieved fame before in the Italian Renaissance – the fourteenth-century painter Giotto, for example, was discovered as a young shepherd sketching in the earth with a stick. But Gentileschi is not bragging about a son. The marvel is his daughter, Artemisia:

> And this girl, as it pleases God, having been educated in the art of painting, in three years has become so accomplished that I would dare to say that she has no equal for she now executes such works as perhaps the leading *Mastri* of this profession have not reached for their level of skill...

The Italian Renaissance had produced women artists before Orazio's daughter. Giorgio Vasari in the enlarged edition of the *Lives of the Most Excellent Painters, Sculptors and Architects* had found room for four, all squeezed in the same chapter, of whom the most highly regarded today is the witty portraitist Sofonisba Anguissola. Another fine female painter of the late Renaissance was Lavinia Fontana, who also specialized in portraits. Artemisia would make a much more original and ambitious contribution, consciously competing with the greatest masters in complex and perturbing retellings of history and myth. Painting was in her blood. She grew

up surrounded by such pigments as lead white, red and yellow ochre, umber and vermilion, in a home that was also her father's studio, frequented by a lawless gang who were revolutionizing the art of painting. Another pigment she'd have encountered was carbon black. Plenty of carbon black.

* * *

The libellous verses appeared without warning, posted up in the dead of night. It was a recognized form of expression in a city that sometimes felt like a chaotic nest built by parasites on the ancient, decaying body of an older, grander metropolis. The astonishing remains of the Forum and Colosseum reminded modern Romans how far they still had to go, at the start of the 1600s, to match the antique splendour of the Roman Empire. A less imposing Roman relic was a time-eroded statue nicknamed Pasquino, on whose mouldering marble remains it was permitted to post satirical verses. The particular 'pasquinades' that elicited sniggers in the unlit, sewerless and still largely fountainless streets of Rome in 1603, however, went beyond what their target in this case – Giovanni Baglione – could endure. Baglione was a painter with a reputation to protect – and the poems that had appeared accused him of being incompetent. 'Giovan Bagaglia', one of them started:

> you are ignorant,
> your pictures are not painterly,
> and I can tell you won't earn anything for them
> Not even the cloth to make breeches
> To cover your arse...
> Pardon me for not joining in the adulation
> For you are unworthy of the chain you wear
> And you disgrace the art of painting.

Baglione had a pretty good idea who was behind these words and he denounced them before the magistrates. When his libel case came to trial on 28 August 1603, the three accused were rival artists whom Baglione claimed were motivated by *invidia* of his fame and success. They were Michelangelo Merisi da Caravaggio and his 'friends and followers' Onorio Longhi and Orazio Gentileschi.

It had all started, Orazio Gentileschi told his interrogators in prison, when he painted a canvas of the archangel Saint Michael for San Giovanni, the Florentine church in Rome. Baglione had then placed opposite this picture, 'a Divine Love that he painted to rival a Profane Love by Caravaggio'.

In the 'Profane Love' – all too profane – that Caravaggio had recently executed for his aristocratic admirer, Vincenzo Giustiniani, a naked adolescent boy posing as Cupid straddles a heap of discarded artefacts of civilization, including musical instruments and an architect's set square. *Amor vincit omnia* – Love conquers all things – as the Roman poet Virgil put it. Yet there's nothing classical about this Cupid. He's a cynical street urchin with jet black wings who's broken into your palazzo to wreck your life. Baglione's reply was as pointed as it was artistically leaden: a stern figure of Divine Love intervening to save Caravaggio's Cupid from mortal sin.

Divine Love Overcoming the World, the Flesh and the Devil caricatures the dark-haired, dark-eyed Caravaggio as a devil being separated from his catamite by the angel of the Lord. This painting accuses Caravaggio of sodomy: a sin and a capital crime. Baglione, far from being the victim of envy, had cause to be jealous of Caravaggio. It was Caravaggio who was taking Rome by storm. Whereas Caravaggio painted his Cupid for the art collector Giustiniani, Baglione dedicated his holy antidote to Giustiniani's brother, a cardinal.

Gentileschi continued that:

although it didn't go down as well as Michelangelo's, it was still said the Cardinal gave him a chain. I told him there was a lot wrong with this picture because he'd painted a man in armour instead of a naked child. Later he repainted it as a nude. I've not spoken to Baglione since...

Baglione had indeed prissily given his angel an awkward-looking suit of armour. Gentileschi's words must have bitten, for in the second version of the picture the angel's leg is exposed. But Baglione also turns the head of an originally faceless satyr so that we can see it is Caravaggio. And that provoked Gentileschi, Longhi and Caravaggio to pen their insults.

Baglione's resentment still smoulders in a biography of his old enemy that he wrote years later. At the start of the 1600s, it relates, Caravaggio stunned Rome with two big paintings of the Calling and Martyrdom of Saint Matthew for the Contarelli Chapel in San Luigi dei Francesi, the French church in Rome. No one had seen anything like them before. Crowds came to see Caravaggio's depictions of louts gathered round a table counting money like thieves after a job, and a near-nude executioner raising his sword over the sprawled Matthew: these dramatically lit tableaux of biting reality 'gave the fame of Caravaggio a boost and were lauded to the skies by wicked people (*maligni*).'

Those *maligni* included connoisseur cardinals, avant-garde aristocrats and other artists. The street theatre, severe lighting and electrifying rawness of Caravaggio's paintings would inspire dozens of disciples and reignite European painting as his cult spread as far afield as Utrecht, Seville and Toulouse. What the libel case shows is that already in 1603, just three years after the Matthew paintings

made him a star, Caravaggio had followers. It also gives us a glimpse of them acting like a street gang.

Onorio Longhi, named in the trial as the other of Caravaggio's *amici et adherenti,* would be in court again that November after confronting Baglione in the church of Santa Maria sopra Minerva, and trying to start a sword fight. His tough ways mirrored the behaviour of Caravaggio himself, who was not just a cutting edge artist but an expert swordsman.

Gentileschi followed Caravaggio more for his artistic genius than his swordfighting skills. He was older than the mercurial man whose art entranced him. Born in Pisa in 1563, he was 40 in the year of the libel case. Caravaggio was 32. But the older man was more than happy to recognize his younger friend's startling originality, and learn from it. He saw the tenderness behind Caravaggio's art of shock. In about 1596, Caravaggio portrayed himself as Saint Francis of Assisi, robed in a friar's habit, swooning in ecstasy in the arms of an angel who is all too visibly a young male model wearing strap-on wings. Gentileschi painted his own interpretation of this dreamy scene, repeating the subject several times over. He also painted a Madonna and Child, from about 1605 to 1610, that pays subtle homage to another early introspective masterpiece by Caravaggio, a painting of a prostitute as the Penitent Magdalene. Both are closely observed and intimate, blurring the boundary between religious art and secular portraiture – pictures of real women rather than holy personages.

Gentileschi, who was born with the surname Lomi, was the son of a goldsmith whose proudest moment was making a crown for Cosimo I, Grand Duke of Tuscany. It was not unusual for a jeweller's son to become an artist. The Florentine sculptor-goldsmith Benvenuto Cellini made both salt cellars and statues. Orazio's half-brother Aurelio Lomi also became a painter and spent his life creating complicated colourful altarpieces for Tuscan churches. Orazio himself was a slow

starter. He settled in Rome in the late 1570s after his father died and took the name Gentileschi from an uncle. He worked on frescoes for the Vatican Library in the late 1580s and painted *The Presentation of Christ* for Santa Maria Maggiore in 1593, but his work before 1600 has left little mark. When he encountered Caravaggio it changed his life. Caravaggio transformed him as a painter.

Gentileschi's fierce loyalty to his friend blazes in his testimony in the 1603 trial. Caravaggio knew the ropes and handled himself like a taciturn habitual criminal. He didn't name Gentileschi among the painters he admired. Indeed he claimed they hadn't spoken for years. Gentileschi tried the same trick, complaining that Caravaggio never greeted him with a doff of the cap – a plausible description of the surly streetfighter's behaviour.

But Gentileschi was not a good liar. In his testimony he harped on Baglione being given a chain to honour his work: 'For you are unworthy of the chain you wear...' Clearly, Gentileschi was fully involved in this verbal war on the streets. His testimony gives one incongruously sweet glimpse of his friendship with Caravaggio. While dutifully denying they've had contact lately, he can't help mentioning that Caravaggio recently borrowed from his house a Capuchin monk's costume and 'a pair of wings, which he sent back to me about ten days ago'. It's a lovely image of the way they were both painting at this revolutionary moment in Italian art. Gentileschi had been brought up in the Florentine Renaissance tradition that a painting should be planned and constructed in a series of preparatory drawings, but here he was, sharing props and costumes with Caravaggio as they tried to catch real life on canvas.

Artemisia Gentileschi was ten years old when Caravaggio returned the wings. The fact that her father had a home with space not just to paint but to store costumes and props reveals how different

his aspirations were compared to Caravaggio's. In 1603, Caravaggio was living in the same unstable way that he had since coming to Rome in the early 1590s, with periods as a guest in great men's palaces alternating with brief rentals. He never married. Orazio, by contrast, lived in the way men were expected to in early modern Europe, as the head of a family, just like his craftsman father. His wife was Prudentia Montoni, a native Roman. On 8 July 1593 she gave birth to their first child, and two days later the girl was baptized in the church of San Lorenzo in Lucina. Her exhausted mother was unlikely to have attended. The daughter was named Artemisia after her godmother, Artemisia Capizucchi. It was an absolutely typical, respectable start in life.

Artemisia would have been born at home. It was a moment when her mother's female friends and relatives – including her godmother – must have gathered to offer support and help, sharing their own experiences of the most dramatic and dangerous moment in Renaissance women's lives. An entire genre of painting depicted this rite of passage and its female social setting. It takes over depictions of the births of the Virgin Mary and John the Baptist. In Artemisia's own mature work *The Birth of Saint John the Baptist* it becomes a realistic contemporary scene of what, in an age without anything we'd recognize as decent medicine, could easily end tragically for mother and child. In Artemisia's depiction, two women sit in their best clothes, recognizing the specialness of the moment, while two are busy working as midwives with their sleeves rolled up, one with a bowl of water, the other presenting the newborn to – perhaps – his godmother.

Surviving birth was an achievement in itself. The reason Artemisia was baptized so soon after being born was that the high infant mortality of this period made it a sensible precaution. Babies who died unbaptized were doomed to get stuck in Limbo, instead of ascending to Paradise like baptized innocents.

Having survived life's first hurdle, Artemisia spent her early years in the family home on Via di Ripetta, not far from the Hospital of San Giacomo of the Incurables, which treated Romans with syphilis. Via Ripetta was one of three long, straight streets, together with the Via del Corso and the Via Paolina, that radiated southeast from one of Rome's biggest public spaces, Piazza del Popolo. The area defined by these streets became known as Il Tridente, 'the Trident', because it looks from above like Neptune's three-pronged trident spearing the city. This impressive piece of town planning was the first serious effort by the Renaissance popes to impose clarity on the chaos of ruins, opportunistic building, pasture and orchards that was medieval Rome. It gave direct access through the tangle to Rome's most sacred churches. Pilgrims entering the city through the Porta del Popolo would be awed by the piazza with its obelisk before heading down Via Paolina towards Santa Maria Maggiore; or along Via del Corso to St John Lateran, the archbasilica frescoed by Orazio in 1599 and where the 11-year-old Artemisia underwent her confirmation into the adult congregation. Or you could go down Via di Ripetta towards St Peter's, which at the time of Artemisia's birth was entering the final phase of its completion.

Until the age of 18 this was where Artemisia lived, albeit at different addresses. After Via Ripetta the family moved to nearby Piazza Santa Trinità, then Via Paolina, which everyone referred to by what has now become its official name, Via del Babuino (Street of the Baboon), after an ugly statue of Silenus on a fountain. Annual censuses undertaken by churches at Easter reveal that the area was inhabited by painters, their apprentices, paint grinders, models and paint sellers, living alongside cabinet-makers, cooks, washerwomen, vineyard workers, barbers, builders and *cortegane* (sex-workers). And while the Corso was an artery that served to unify Rome, it was also the site of the popular and unruly annual carnival that marked the beginning of Lent. Artemisia

would have witnessed the rowdy festivities that involved races on the Corso, including the notorious Jews' Race.

Artemisia also grew up close to some of Rome's greatest art. Piazza del Popolo was home to the Gentileschis' parochial church, Santa Maria del Popolo, whose Augustinian friars had pastoral care over their neighbourhood. It had been rebuilt in the early 1500s by the pioneering classical architect Bramante and was home to the ornate Chigi Chapel, begun by Raphael. But the most gripping works of art in the church were the most modern, by her father's friend Caravaggio, who in 1601 painted two canvases for the side walls of its Cerasi Chapel.

These hallucinatory masterpieces face each other like two windows onto glaringly lit torture chambers. To the left, the tax collector Saul lies cast down on the ground by an illumination from God. Opposing this cataclysmic redemption is a revelation of horror. In the blackness of a catacomb, Saint Peter is being crucified upside down. As two workers struggle to raise the cross with him already nailed to it – you can't help sympathizing with their tough job – he looks with wide open eyes at the nail through his hand. It's clear from echoes of it in Artemisia's works that she must have looked at this painting until it burned into her mind.

When she was 12, Artemisia's relationship with Santa Maria del Popolo took on an even blacker hue than the void in which Caravaggio's Saint Peter suffers. On 26 December 1605, her mother died in childbirth. She was buried in Santa Maria del Popolo. Prudentia had by then had three more children who survived and two who had died in infancy. All were male. Artemisia's living brothers were Francesco, born in 1597, Giulio, born in 1599, and Marco, born in 1604. The dead ones were both baptized Giovanni Battista.

The power of religious art in the seventeenth century can't be understood without a sense of the acute fragility of life before modern

times. Cities were rife with disease, fetid with human detritus, prone to fire. Life was a flickering candle. Prayer was desperate, not complacent. Caravaggio's scenes, set within mysterious darkness, reflect that embattled mood.

Yet religious art served imperatives from above as well as needs from below. In the second half of the sixteenth century the Catholic Church needed to renew itself. The Protestant Reformation begun by Martin Luther had removed much of northern Europe from the Catholic flock. The Council of Trent was called by the Papacy to restate Catholicism against the northern heretics. It declared that good works were the road to grace, along with prayer and confession. Sacred art was positively encouraged, especially as reading the Bible was confined to the clergy. Yet the Counter-Reformation, as the movement to renew the Catholic Church is known, was not just a set of rules handed down by the Council of Trent's final report in 1563. It was a grassroots movement that inspired men and women to become saints. Teresa of Ávila, Charles Borromeo, Filippo Neri and Ignatius of Loyola sought rapturous transports of the soul that breathed new fire into the Church. By the time Artemisia was growing up they were already cult figures in Rome, commemorated by churches such as the Gesù and the Chiesa Nuova, literally the New Church.

Artists took decades to come to terms with the new piety. Their eventual success began with an archaeological discovery. In 1599 the tomb of the early Christian martyr Saint Cecilia, patron of music, was opened in the church of Santa Cecilia in Trastevere in Rome. The body, claimed witnesses, was perfectly preserved after a millennium. The sculptor Stefano Maderno carved an acutely lifelike, or deathlike, figure of Cecilia as she was found lying in her tomb, covered in a shroud that follows the contours of her uncorrupted flesh. Creepy stuff – but with a raw, tragic appeal. It's art for the emotions and all you need to appreciate it is to be human.

Artemisia was a child of the Counter-Reformation. From documentary evidence we know that her life was narrowly circumscribed. She spent almost all her time at home except for walks to Mass. At the age of 19 she still hadn't been taught to read or write. An illiterate girl who looked at the pictures in churches and heard the holy stories told by priests was almost the ideal target for the emotive piety of the Counter-Reformation. This piety was personal. She would have been encouraged to identify with the female martyrs in paintings and sermons: Cecilia and Catherine, Lucy and Agatha.

It sounds like the upbringing of a nun. And Orazio, according to his lodger, wanted such a life for Artemisia, even after he had started her training as a painter – Artemisia was reportedly hostile to the idea. Orazio's confusions are understandable. Nuns engaged in business, agriculture, worked as apothecaries, and they could paint; one of the female artists Vasari praises is Sister Plautilla Nelli. They didn't die in childbirth. A life as a painter in the secular world was an outlandish choice for a girl, especially one from such a relatively low social background. Women were excluded from professional organizations of artists. The Academy of Saint Luke, to which Orazio belonged, had a very few women as associate members but they were not permitted to attend meetings. Women could not undertake professional contracts in their own right; even ordering art supplies required a male guarantor.

Orazio's hesitancy is probably reflected in the late start – by Renaissance standards – of Artemisia's training, in the year she turned 16. Had the pressure to pass on his craft come from Artemisia herself? Had she pestered him for chalk and charcoal in his painting room while her younger brothers were trying on wings? Vasari's tales of artists begin with their first signs of talent. Michelangelo, for instance, was always drawing as a kid. His snobbish family tried to beat it out of him before agreeing to apprentice him to Ghirlandaio at the age of 13.

So perhaps Artemisia had to fight to get her father to take her ambition seriously. He probably put more hope in his sons, but by 1612 he was ready to recognize that she alone had a gift. It's fair to say the Gentileschi boys would prove a disappointment.

Where did she ever get the idea that she wanted to paint? Apart from watching her father, she'd have encountered his artist friends, including Caravaggio, when they visited the house. But perhaps the loss of her mother was also a factor. The death of Prudentia must have left a sad household on Via Paolina. Orazio didn't remarry, and we know that he worried about his daughter's isolation from female company in what was now an all-male household.

One of Artemisia's earliest surviving works is a painting of the Virgin and Child, perhaps begun in 1609. With its pink and blue draperies and sweet atmosphere, it is more of a prayer card than a Caravaggio. The face of Mary looks like later images of Artemisia herself – which may perhaps mean it also resembles her mother. The baby on her lap reaches up and passionately touches her face, caressing her and gazing into her eyes. It is an image of the child's longing. Christ may be standing in for the artist herself. He touches his mother's flesh and looks into her eyes, in a way that Artemisia could no longer touch or see her own mother. If that's a fair reading, Artemisia's art begins as the most primal act of magic: an attempt to raise the dead.

In 1606, Caravaggio's Roman career of edgy art and edgier living came to a bloody end when he killed a man in a swordfight. Onorio Longhi, one of the writers of rude verses, was also involved. Caravaggio fled Rome for southern Italy and would die on the run. Any personal contact Artemisia had with him therefore came to an end. It was her father's interpretation of Caravaggio's style, instead, that loomed large as he gave her detailed lessons. By now he was no more marked by Caravaggio than any of Rome's rivalrous

crowd of coming artists. In the early 1600s every ambitious painter tried Caravaggio on for size. Just before Caravaggio fled Rome, the sensitive Bologna-born colourist Guido Reni painted a homage to one of his goriest themes, *David with the Head of Goliath*. The painting exults in the surreal contrast between the outsized head and the partially naked youth who calmly considers his trophy. Reni also channelled Caravaggio when he painted a swordsman about to kill Saint Catherine of Alexandria: the blade hangs glittering against the dark, about to scythe towards the accepting female martyr with her heavenward gaze.

Reni's Caravaggesque paintings respond to the violence of their inspiration. Orazio Gentileschi's don't. He saw a gentleness in Caravaggio. His first responses to his hero's art included tender visions of Saint Francis. By now he was painting ambitious religious narratives that combined acute realism with uplifting Baroque theatre. Between 1605 and 1607 he painted *The Circumcision of Christ*, a miraculous juxtaposition of everyday life and the supernatural. As a crowd of sharply observed witnesses gather round to see an infant circumcized, puffy clouds float in a sky of unreal azure, while God himself looks down from a heaven that's just a prayer away. This painting's mix of realism and dream is a bit awkward, if truth be told. Orazio portrays angels in the court of heaven with the same skilled observation he brings to the humans below, and it undermines their holiness. Is he offering mysticism or kitchen sink? Raw life or classicism? He's not sure, and this confusion was gradually to paralyze his art.

But for now, Orazio was on top of his game in a Rome bursting with artistic opportunity. In 1605 Camillo Borghese was elected Pope Paul V, inaugurating a consciously triumphal reign that saw the Counter-Reformation set in stone, with Rome as the centre of a resurgent Catholic world. Paul V canonized the Catholic visionaries

of the previous century, but he and his aesthete nephew Cardinal Scipione Borghese also lavished money on palaces and gardens and frescoes to fill these sumptuous spaces. The Baroque age had truly begun and it would turn Rome into an unreal city of cascading fountains and spiralling staircases.

Orazio was competing for a place in this new Rome and what he offered was a graceful classicism with a pepper of Caravaggesque seasoning. And this is what he taught Artemisia. Her first signed and dated painting shows how thoroughly she had assimilated his skills. In addition to her boldly written signature – big like the signature of someone who couldn't write – it is inscribed 1610. That was the year she turned 17. Orazio's boasts were justified.

It is a painting of Susanna and the Elders, a story from the Book of Daniel that had been popular in art for centuries. Susanna, the virtuous wife of a good man, was spied on in her garden by two greybeard judges who 'perverted' their minds from God – as the King James translation of 1611 has it – in their 'lust'. When, thinking herself alone and unobserved on a hot evening, she stripped off to bathe, they pounced. Susanna must have sex with them, insisted the elders, or they would say they had caught her with a lover.

Artemisia's painting of the two lustful men who have crept right up to Susanna is a consummate exercise in her father's style. Behind the two encroaching men is a sky dappled with cotton wool clouds much like the blue yonder in Orazio's *Circumcision of Christ*. The classical stone wall against which Susanna sits also resembles Orazio's barriers between foreground and sky. And yet, this painting has details for which there's no precedent in his art.

In spite of upbraiding Baglione for failing to make his Divine Love naked, Orazio Gentileschi was not inclined to strip his own models. He came of age in the strictest years of the Counter-Reformation, when nudity in religious art was frowned upon. This

new puritanism had hit the Italian art world in a chilling way when Michelangelo was accused of turning the Sistine Chapel into a 'bath house' of male nudes in his altar wall fresco of the *Last Judgement*, finished in 1541. Sixty years later, Caravaggio's depiction of *Saint Matthew and the Angel* for San Luigi dei Francesi had to be repainted because Matthew was showing too much leg. Orazio carefully covers up his figures; even his infant Christs of the early 1600s are heavily clothed. By 1609 the mood was changing under the new Borghese Pope. In his later career, Orazio would become an accomplished artist of the female nude. But his sartorial caution shows what a timid Caravaggist he really was.

Artemisia's *Susanna* unveils a bolder artist than her father. *Susanna and the Elders* became popular in the wake of the Counter-Reformation precisely because it let artists dramatize conscious and unconscious anxieties about nudity, voyeurism and lust. The passionately Catholic Venetian master Tintoretto painted a dazzling version between 1555 and 1556 in which the two peeping toms creep around both ends of a hedge that's painted side on to the picture surface in disorienting perspective. His Susanna is a Venetian beauty for the eye to admire, and yet we're warned that in looking we resemble those two dirty old men. Tintoretto also gives Susanna a mirror to contemplate herself. Is that how Artemisia painted her Susanna? Did she have a mirror in front of her?

This is one way that Artemisia changes art: simply by being female. When she paints a naked woman, it's different from a man doing so. It's not only that, as a teenager painting in her bedroom, she can use herself as a model – she sees the entire scene from a different point of view. Tintoretto sympathizes with Susanna but he also enjoys her. Artemisia, by contrast, paints this as a scene of sheer torture. The young woman raises her hands to shield herself from these two men who hunch over the wall so oppressively close to her.

That wall should mark off her private space, her secret world. Instead they intrude, unapologetic and conspiratorial. One of them, oddly, is too young for an 'elder', with a mane of thick black hair. Susanna lowers her face in agony while his right hand rests near her hair.

Susanna's downcast face and raised hands reveal another of Artemisia's artistic heroes – one whose works a young Roman could scarcely avoid: Michelangelo Buonarroti. When Michelangelo died in 1564, his design for the dome of St Peter's was on the way to being built. By Artemisia's childhood it dominated the skyline across the Tiber. Michelangelo's frescoes in the Sistine Chapel were famed throughout Europe. Even if she never entered the Pope's chapel, she could study Michelangelo's designs in prints. Susanna adopts the pose of Adam being expelled from Paradise on the Sistine ceiling. Just as Adam holds up his hands and turns his head away from the angel who casts him and Eve into the wilderness, so she makes the same gesture to repel her oppressors.

To quote Michelangelo was to make a statement of intent. The fifteenth-century art theorist Leon Battista Alberti stated that the loftiest branch of painting was the 'history', or complex narrative. The greatest painter of histories was recognized to be Michelangelo, in his Sistine Chapel frescoes. Right from the start, Artemisia asserts herself as a history painter, telling stories that matter. A heroic artist, in Michelangelo's mode. Michelangelo painted as many nudes as he liked and expressed his own feelings in his art. So would she.

Yet those feelings are carbon-black. This is a painting of oppression, fear and shame. What was freezing her in such eloquent pain?

2

Judith

Perhaps Orazio was trying to fill the hole left by Caravaggio. Maybe the troublemaking, loudmouthed painter reminded him of the cursed genius who died that year, at the age of 38, on a doomed journey back to Rome. As one maverick died, another took his place in Gentileschi's life. The consequences for Artemisia, however, would be extreme and are laid out in detail in a document of 1612 in the State Archive in Rome that chronicles, witness by witness, the trial of the man who raped her. The story that emerges from this trial transcript is a sordid tale of a sexual conspiracy by older men against a teenager. Yet it has up to now been widely misunderstood. It is often repeated that Tassi got access to Artemisia because he was her teacher. This is a complete misreading of the evidence that the judges heard. It conceals a much more nightmarish and sinister affair. Susanna and the Elders, even.

In June 1610, the artist Agostino Tassi arrived in Rome from the Medici port of Livorno bringing with him an eccentric 'family' consisting of his wife's sister Costanza and her husband, his apprentice Filippo Franchini. They all moved in with Tassi's sister Olimpia and her husband. Tassi was a vicious enough character to pass for Caravaggesque. His teenaged sister-in-law may have been pregnant by him when they reached Rome. Meanwhile, he was arranging for assassins to kill his wife, Maria Cannodoli, who had run away.

Caravaggio's paintings mirrored his violent life in a way that makes them tragically compelling, but the paradoxical Tassi painted

gentle landscapes and fantasy nautical scenes. He also had a very marketable skill in constructing perspective illusions of deep space in frescoes on walls and ceilings. This talent for *quadratura*, as such perspective science was called, required excellent mathematics, so Tassi must have had a brain. He used it to boast and bend the truth, earning himself the nickname *Lo Smargiasso*, 'the Braggart'.

His big talk certainly bamboozled Orazio Gentileschi. Having come from Tuscany, Tassi promised to get Orazio in with the Medici family, recalled Orazio with bitterness:

> He led me to believe he wished to introduce me, through the intermediary of Signor Lorenzo Usimbardi, into the service of their Serene Highnesses. In a short time he showed himself to be a passionate friend; and with a reciprocal affection not only did I love him but carried on even when he was imprisoned for a sexual crime with one of his sisters-in-law, and by effective methods I freed him from the gallows.

This test of their friendship came about in February 1611, when Tassi fell out with his sister over money and she accused him of incest with Costanza. The Council of Trent had determined that incest included relationships with in-laws so it carried the death penalty. Tassi was imprisoned. Orazio was blinded by friendship's 'love', and supported him – his exaggerated claim to have saved him may reflect a telling naivety about the mechanics of power in papal Rome. By the end of March Tassi was free. His escape cemented their relationship as they started working together on frescoes on Rome's Quirinal Hill.

Widely known as Monte Cavallo – Horse Mountain – because of two ancient statues of the heroic horsemen Castor and Pollux that stood atop it (and still do), the Quirinal was being developed into

a lofty locus of splendour by the Borghese. Rome was an unhealthy place to be in summer. The Tiber became fetid and malaria was rife: as late as the nineteenth century it would kill a fictional tourist, Henry James's Daisy Miller, after she foolishly visited the Forum by night. It may also have been malaria that brought low Pope Alexander VI and his son Cesare Borgia after dining by the river. So in the late sixteenth century the Papacy established a summer palace on top of the Quirinal, where the air was believed to be healthier.

Tassi and Orazio Gentileschi worked together from February 1611 on frescoes for the summer palace and, from September, on Cardinal Scipione Borghese's garden palace next to it. They painted its Casino of the Muses, with Orazio's figures inhabiting an illusory architecture created by Tassi.

One of those figures is a young woman who stands, hand on hip, her hair hanging loose. This looks like an affectionate portrait of a real person – and resembles later images of Artemisia. If this is her father's portrait of her, it's a witty image of a confident character.

Tassi would later self-pityingly describe himself as caught in a 'labyrinth', but if anyone was trapped in a labyrinth it was Artemisia. Its architect was an older man who, in his letter to the Grand Duchess of Tuscany, Orazio called 'one of my most powerful enemies'.

This was Cosimo Quorli. It was certainly Quorli, not Orazio, who had rescued Tassi from the gallows. He appeared to wield a great deal of informal power as a consequence of his job as *furiere* or quartermaster to the Pope, a role he'd held since 1595, giving him responsibility over furnishings in the papal palaces. He'd also been a defence witness for Caravaggio in a court case in 1605, after the painter was accused of stealing a carpet. An important witness to the events that would engulf Artemisia claimed that Quorli had been plotting his scheme against the Gentileschis as soon as Tassi arrived in Rome – that is, as far back as June 1610.

Why? The question is as difficult to answer as why Iago plots against Othello. Quorli already knew Tassi, and had history with Orazio. Artemisia herself was all too familiar with Quorli, a man she considered repugnant. Orazio on the other hand seems to have seen him as another 'passionate' friend; Quorli and Tassi would regularly take Orazio out drinking until 'the fifth hour of the night'.

That at least was the tale told by Tuzia Medaglia, a woman whom Orazio would accuse of being the third member of what amounted to a conspiracy. Orazio had got to know Tuzia when they lived across the street from each other on Via Margutta. As well as young sons, Tuzia had a daughter close in age to Artemisia and they became friends. So relieved was Orazio that the motherless Artemisia now had some female company that when the Gentileschi household moved in April 1611 to Via della Croce, he invited Tuzia and her family to join them. In retrospect, Orazio's poor judgement of character seems limitless.

Quorli's plans for Artemisia and Tassi to meet kicked off in April 1611 when his wife – she was involved too – turned up in a carriage at Artemisia's home to take her out. Artemisia sent a message to her father as he worked to ask his permission. He gave it, so Artemisia, Quorli's wife and children, Tassi's sister-in-law, Artemisia's brother Giulio, Tuzia and her children all set off to see Orazio's and Tassi's frescoes on Monte Cavallo. Tuzia, though not Artemisia, recalled that Artemisia held hands with Tassi's sister-in-law Costanza and that Artemisia played a game with the other women in a small garden. Afterwards they went for lunch at Quorli's house, across the river, near St Peter's, with Orazio, Tassi and Quorli walking behind the carriage. Tassi and Artemisia do not seem to have spoken.

Artemisia would recall that after this, Tuzia encouraged her to talk privately with Tassi, describing him as a 'courteous and gallant youth' (Tassi was 35). He specifically wished to warn her about a former servant, Francesco Scarpellino, who was spreading rumours

about her, claiming she'd given him sexual favours. On the day of Santa Croce, 3 May 1611, Tuzia admitted Tassi to the house when Orazio was out and Artemisia agreed to listen to his reports about Francesco: 'I replied to him that it was of little import to me what Francesco had said because I knew how things stood with me and I was a maiden (*zitella*).'

Tassi said he was upset by Francesco's claims, reported Artemisia, because of 'the friendship he had with my father'. He left, but this was just the start of his intrusion. Artemisia was still in bed the next morning when Tassi turned up again – this time accompanied by Quorli. He too started telling Artemisia what a fine *giovane* Tassi was. When she expressed her abhorrence of Quorli to his face he revealed his appetite for the obscene. 'After giving it to so many you can give it to him', said the Pope's servant. She asked him to leave, 'and turned my back on him'.

Soon afterwards, Quorli and Tassi left. This was a sinister invasion of the supposedly safe space of the family home where she spent so much of her time. Artemisia was disturbed (*sturbata*) but wouldn't say why, which upset her father. So he listened when Tuzia said he should make his daughter take a short walk, claiming it was unhealthy to always stay in the house. Tassi then sent a message in the evening via one of Tuzia's boys that he wanted to meet Artemisia; she dismissed it out of hand. The next day Orazio told Tuzia to take his daughter to visit St John Lateran, the ancient cathedral of Rome. As they were getting ready, Quorli and Tassi appeared again. An alternative outing to a vineyard was proposed but Artemisia rejected it angrily as this was traditionally considered a lovers' meeting place. Tuzia and Artemisia went alone to the cathedral, only for Artemisia to spot the two men hanging around once they arrived.

According to Tuzia, Quorli and Tassi got her younger brother Francesco to linger behind by buying him *ciambelle* (doughnuts).

When Artemisia left, Tassi walked after her all the way home, in spite of her asking him to stop. Back at the house, the parish fathers came with communion cards and left the door open, which allowed Tassi to follow them; he whispered behind their backs that he'd like to 'beat them'. When they'd gone he told Artemisia she'd been unkind to him and she would 'repent' it.

That afternoon Tassi came back. Artemisia had eaten lunch and was painting a portrait of one of Tuzia's sons 'for my enjoyment'. Tassi got in through a door left open by workmen 'and having found me painting said to me: "Don't paint so much, don't paint so much." And he lifted the palette and brushes from my hands and threw them here and there and said to Tuzia: "Get out of here!"' Before they were alone he rested his head on Artemisia's chest, and when Tuzia left he took Artemisia's hand. He insisted they walk around the room a few times. Each time they went round they passed her bedroom door. 'I've got the fever more than you', he insisted when she told him that walking in circles made her feel sick. Finally, he thrust her into her bedroom and locked the door behind them.

Tassi pushed the 17-year-old Artemisia onto the bed, where he held her down and raped her, placing his knee between her thighs and stuffing a handkerchief in her mouth to stop her screaming. It hurt, very much. Despite the handkerchief she tried to call for Tuzia; she scratched his face, pulled his hair and, when he tried to penetrate her again, she gouged at his penis. Afterwards she found a knife in a table drawer and threw it at his chest, wounding him slightly. Artemisia cried and Tassi promised to marry her, warning her that he didn't want any foolishness when they were married.

As they were now 'engaged', Tassi expected her to carry on sleeping with him in secret, while he and her father were working on the frescoes on the Quirinal. Quorli now also attempted to rape her, more than once, but she managed to fight off the old man.

An older and a younger man conspiring to subject a young woman to sexual terror and humiliation – it's hard to disassociate Artemisia's experiences of 1611 from her painting of *Susanna and the Elders* of 1610. Is it possible that the illiterate young painter made a slip about the year, or did she continue working on the painting after its inscribed completion date? What we do know is that between 1611 and 1612, Artemisia got to experience the plight of Susanna at first hand.

In July 1611 the Gentileschi household, including Tuzia and her family, moved from the area where Artemisia had spent her entire life, close to the heart of papal power. It was also where Tassi and Quorli lived. Perhaps Orazio thought it would help him get commissions from the Pope. But the locality's grandeur contrasted with the seedy goings-on in the Gentileschi home. Orazio, oblivious to what was happening, had a door made to connect Tuzia's apartment with the family quarters. That meant Tuzia could allow Tassi through her flat to visit Artemisia. This happened repeatedly. In August, as she was going by carriage to St John Lateran, Tassi jumped inside and redirected the driver to San Paolo Fuori le Mura, a church in the countryside outside Rome where they went for a walk in the fields. It was a humiliatingly public allusion to their secret relationship.

At the end of the year, Cosimo Quorli, surely to spy on the Gentileschis and to smooth Tassi's path but also presumably a piece of power-play, arranged for his cousin Giovanni Battista Stiattesi, an impoverished Florentine notary, and his family to live with Orazio. It was a misjudgement. Stiattesi loathed Quorli, and Artemisia found herself able to tell Stiattesi and his wife what she could not tell her father.

It all came to a head in early March 1612, at carnival time. Throughout Catholic Europe, carnival was the most disorderly of

shared rituals. With roots deep in the Middle Ages, perhaps even in ancient pagan rites, it was a time when authority vanished and the world was turned upside down. In Rome, as elsewhere, masks were worn as a symbol that the social norms were suspended. Cosimo Quorli seems to have fancied himself as king of carnival. He paid for comedies and parties at his house. And Artemisia was to be part of the entertainment.

By this time a confounding number of people, including Tassi's sister-in-law and mistress Costanza and Quorli's wife, seem to have been in on the joke they were making of the young painter. Taken to Quorli's house for a carnival party with her family by Costanza, Artemisia was led by Quorli's wife to a room where she was left with Tassi. It was the same room where a carnival play had been staged – as if this too was a grotesque comedy. Quorli stood guard in case Orazio showed up. Eventually Quorli declared in front of a large number of witnesses, 'It's your own fault if you haven't done it.'

Even Orazio couldn't remain blind any longer.

But this wasn't Quorli's only carnival joke. A few days before carnival, Artemisia had sent a painting of the biblical heroine Judith to Tassi. At the same party, Quorli forged a letter from Artemisia to be sent to Tassi's household, telling them to hand it over to Quorli, and the prank worked.

* * *

The young women have a tough job. It requires all their attention and all their physical strength. Luckily they are both muscular. One is up on the bed, pressing down, concentrating her body weight in two thick arms that pinion the bearded man beneath her. She holds him helpless, even though he is fighting for his life with the last energy in his bleeding body. His eyes are open and conscious. He

knows what is happening to him. He tries to scream but the damage to his throat makes that impossible. Under his hairy head, rivulets of thick crimson gore stream over the bed's white sheets and flow in a waterfall into the shadows at the bottom of the picture. A second woman is patiently sawing off his head. With her left hand, she holds it, twisting and pulling it down to clear a way in his throat for the sword she has in her other arm. She's already sliced into the soft flesh of his neck, through the aorta and windpipe, and now with both sleeves of her blue dress rolled up above her elbows, she keeps going to sever the remaining bone and muscle and completely decapitate the restrained man. Her face is determined and absorbed, yet also aware of the terror of her just deed. She rears back her entire body, literally keeping the blood at arm's length.

The Book of Judith, a supplementary Old Testament text for Catholics, is a heroic tale of a woman who carried out an undercover mission to kill a persecutor of Israel. Judith was a wise, godly and beautiful widow whose city was besieged by the merciless Assyrian general Holofernes. The men of the city were fatalistic. But Judith, God's assassin, went to the Assyrian camp and won Holofernes' confidence. They spent a relaxed evening alone in his tent, in the course of which he got drunk and she cut his head off. Artemisia Gentileschi's *Judith Slaying Holofernes* in the Capodimonte Museum in Naples is one of the most enthusiastic depictions of this virtuous slaughter ever painted. Its power lies in the meticulous way Artemisia works out the details, as if planning the perfect crime. What would it really take for a young woman like herself to behead a big strong man?

She might need help. Judith's servant Abra is usually shown in medieval and Renaissance art either receiving Holofernes' severed head in a bag, or carrying it behind her mistress as they escape. She does not usually help in the actual killing. Artemisia, however, enlists her as co-decollator. The two women appear equals, rather

than mistress and maid. They are almost doubles. Both are sturdy and young and utterly determined to separate this man's head from his body.

All the paintings by Caravaggio that Artemisia had seen are transfigured in this thought experiment. There were many imitators of his art, yet of all the works of the Caravaggisti, this is the most subversively brilliant. It looks deep into his darkness and comes out with a lurid revelation. It is at once a total assimilation of his influence and a highly personal departure from it. It's clear how carefully Artemisia must have studied Caravaggio's *Crucifixion of Saint Peter* in her parish church Santa Maria del Popolo. For the two women going about their gruelling physical work echo the two men labouring to raise Peter's cross. Not only do they have the same absorption in sheer hard work, but, like Caravaggio's working stiffs, they stand over a man whose face is inverted in suffering.

Yet this painting has a more direct model – and it's in dialogue with it that Artemisia can picture her precise mayhem. Caravaggio's *Judith and Holofernes* in the Barberini Palace, Rome, is a nightmare as clear as life. Holofernes has woken up as Judith cuts through his neck. He raises himself up like a lizard on a crooked arm, his fingers splayed on the bloodstained mattress. Judith, holding back, looks appalled by her own deed. Her servant, in Caravaggio's version, is an old woman whose eyes bulge with horrified fascination as she waits with the sack. With its mesmerizing mimesis and grotesque invention of a Holofernes who is conscious of his grisly fate, Caravaggio's painting makes an old story into tabloid news. And he puts into sharp focus its disconcerting imagery of man-killing.

There had always been something troubling about Judith. In Florence at the start of the sixteenth century an official advocated removing Donatello's fifteenth-century statue of a cowled Judith holding Holofernes by his hair as she towers above him with

sword raised from its symbolically important place because it was considered 'not right that the woman is killing the man'.

This was a blunt statement of a real representational problem. The Biblical Judith is a good and holy woman on a mission to defend God's people. But what if someone took a statue or painting of her at surface value – not as God working through a weak woman as his instrument, but simply a woman killing a man?

Caravaggio's painting does not only make the Book of Judith real and immediate. It goes further. It deliberately confuses the story with the nightmare of actual women rising up against the fathers and husbands who rule them and taking bloody revenge. This had in fact recently happened in Rome when he painted his *Judith*. On 11 September 1599 a young noblewoman called Beatrice Cenci was taken to a scaffold on Ponte Sant'Angelo to die together with her stepmother Lucrezia and brother Giacomo. It seems unlikely that the six-year-old Artemisia was there to watch – but not impossible, for this was a world in which people of all ages witnessed such scenes. Caravaggio was surely there, in a crowd that filled the streets and stood in awed compassion for the doomed Cenci.

Beatrice's crime, along with her family, was to have arranged to kill her father, a notorious monster who had repeatedly raped her as well as male and female servants. The killing of this brute was widely seen as understandable – but the Papal court sentenced the three Cenci to death anyway. After all, it could not be right for a daughter, wife and son to slay the head of the family. Beatrice had to watch Giacomo having his flesh torn off with pincers, his head stove in and his corpse quartered before she and her stepmother were beheaded.

Painted between 1599 and 1600, in the wake of this horror, Caravaggio's painting harps on it insidiously. Instead of being beheaded like Beatrice, the young woman is doing the beheading.

Just like the real-life events that held Rome enthralled when he painted it, his obsidian mirror of a canvas plays on some of the most uneasy thoughts his contemporaries could have. What was stopping women taking revenge on men?

Artemisia didn't need to see the connection with Beatrice Cenci's parricide and punishment to find in Caravaggio's scene a starting point for her own blood-soaked masterpiece. After all, she was involved in a scandal of her own. Her version of *Judith Slaying Holofernes* is raw and strident and in parts crude, as well as damaged and cut down. It has the feeling of an untamed scream. That is exactly what it is, for she painted it in the immediate aftermath of her rape. That's the only explanation for it passing in 1612 between Tassi and Quorli – the very men driving her to paint this carnival of blood.

In the third week of March 1612, Orazio addressed a petition to Pope Paul V filing a suit against Tuzia, Tassi and Quorli on charges of *stuprum e lenocinii*, the rape of a virgin and procurement. He also charged Quorli with the theft of paintings, including a Judith 'of large size'. The case would be heard by the Pope's own court, the Curia. The same body that shaped Canon law for the Catholic world was to judge this case. Tuzia, whom Orazio kept briefly under house arrest, was seized and kept in the Tor di Nona, a prison within the Tiber bend; Tassi was taken on the Via della Lungara and confined at the Corte Savella prison in the same district. Quorli, the papal servant, was not arrested. The rape of a virgin was usually treated as a form of criminal damage that could be recompensed either by the marriage of the perpetrator and their victim, or by the rapist providing a dowry that would facilitate the victim, whose marriageability had been spoiled, finding a suitable husband. Orazio, who compared these events to a murder, wanted something else. He wanted revenge.

In the inquisitorial method of justice used by the authorities of seventeenth-century Rome, the plaintiffs, accused and witnesses

were interrogated separately at their homes, or in prison, by a judge and a deputy, with a notary to take it down. The notary in this case, Decio Cambio, had also recorded the Baglione libel trial. The interrogators' goal was to reach the truth by catching witnesses out in contradictions. Questions were asked in Latin and replies given in Italian. The witnesses for the prosecution were examined first. Artemisia's first testimony was taken on 18 March at her home at Santo Spirito, where she gave an explicit account of her rape. Did she bleed afterwards?

> At the time the said Agostino attacked me I was having my period and therefore I am not able to say certainly to your Lordship whether my vagina bled because of what Agostino did because I did not know much about how these things happen; but it is true that it seemed to me that the blood was redder than usual.

She also said she bled every time they had sex, which Tassi told her was because she had a weak constitution.

She recounted how she then got a knife out of a table drawer – a piece of art equipment? – and threatened him: 'I want to kill you because you've shamed me.'

Artemisia also had to undergo a physical examination by two midwives. They both put their fingers in her vagina, the transcript records, and confirmed that her hymen was broken, indicating that she was no longer a virgin.

The next witness was Tuzia, who pretty much confirmed the details of Artemisia's account, including the outings and visits and Tassi's intrusiveness, which she attributed to love and jealousy. The judges seem to have concluded that she was treacherously weak rather than criminal and sent her scuttling home. Except she no

longer had a home, having been kicked out by Orazio. By the end of March she had found a new address on Via della Scrofa, back on the other side of the Tiber.

On 24 March the judges interviewed Stiattesi, whose evidence would be crucial in the case against Tassi, albeit against his impulses. For Stiattesi was convinced that Cosimo Quorli was the real villain of the piece, inciting Tassi to rape Artemisia, then dissuading him from marrying her. Stiattesi had known Tassi since Livorno and indeed seemed almost half in love with him. He submitted as evidence a series of poems that he claimed he and Tassi had exchanged, as well as reporting their conversations in bed when he'd slept at Tassi's place. But he was clear in supporting Artemisia's account: Quorli's initiative led to Tassi regularly visiting the Gentileschi house when Orazio was out, 'and with this practice Agostino had carnal relations with Artemisia and deflowered her, as he has told me confidentially many times'.

Stiattesi blamed Quorli not just for setting up the whole business but also for preventing Tassi from marrying Artemisia. Tassi loved her, Stiattesi told the interrogators, but for some reason, Quorli had prevented him from doing the decent thing. In bed, Tassi explained how Quorli had got him in this 'labyrinth' – his favourite word again. Quorli, meanwhile, told Stiattesi that their friend could do better than Artemisia. Stiattesi listened in disgust as this corrupt Elder confessed to his own attempt to rape her: 'It's no longer the time that it was, when one day wanting to fuck her I tried with the force of Hercules and she wouldn't give me a little taste.'

Quorli also claimed to Stiattesi and others that he was Artemisia's real father.

Stiattesi provided evidence about one of the stolen paintings, too: 'I know that Artemisia had an uncommissioned painting of a Judith that she sent a few days before to Agostino's house...' Stiattesi

stressed that there was something odd about the painting, which Quorli appropriated for himself during carnival when he turned Artemisia into part of the fun:

> and I know that Cosimo with his chimeras in the last days of Carnival, while Artemisia was in his house, fabricated a command to move it from Agostino's house as if by order of Artemisia, and I was there when Cosimo wrote this in Artemisia's name and with regard to this I told Cosimo off and said he shouldn't take from the hand of a maiden a painting of that sort (*un quadro di quella sorte*).

Stiattesi made the same accusation to Quorli himself in a letter that he submitted as evidence: 'And also you should be ashamed of snatching from that girl a painting of that sort (*un quadro di quella sorte*) as if she was obliged to pay you for having given a copy of her genitalia.'

Whatever this enigmatic accusation means, it's striking that Stiattesi uses the same phrase here about the stolen picture – 'a painting of that sort'. What sort? Homicidal perhaps. If Artemisia's *Judith* was the painting that passed between her, Tassi and Quorli, this means she must have painted it after Tassi raped her, and before the case came to trial.

Early modern Europe was a society – in theory – with a rigid hierarchy that extended from the heavens to the household, where the rule of husbands over wives, parents over children and masters over servants was as absolute as God's command of the cosmos. That was why the new theory of Copernicus, in which the Earth orbited the Sun instead of standing immobile in a stable order of things, caused so much disturbance in Artemisia's Rome.

At carnival, however, the rules didn't apply. Inversion was authorized. If Tassi and Quorli could take advantage of misrule, so

could Artemisia. For one of the archetypal inversions of carnival humour was the woman ruling the man. Artemisia's two women are literally on top of a man, pushing him down. They push this joke to a grotesque extreme, not just mocking the man for a day but killing him forever. Was it the reversal of accepted reality in two women killing a man that made Stiattesi uncomfortable? A painting 'of this sort' should surely stay in Artemisia's room.

Yet there's a more personal side to this painting. If Artemisia gave it to Tassi, it was a poisonous gift. For it doesn't just upturn the social order in abstract. It directly inverts her own description of what Tassi did to her. In her account of being raped she graphically described how he pushed her on the bed, held her down, and lay on top of her. Her account stresses, in precise detail, the sheer force with which he overcame her resistance.

Judith Slaying Holofernes reverses that force. The women hold the man down. Holofernes watches his own death, as Artemisia watched her rape. He is as helpless as she was.

Artemisia also told the judges that she fought back and would have killed Tassi if she could. But instead of glancing off his chest like the knife she threw at him, Judith's sword has found its mark. She keeps cutting.

Tassi's reputation as a braggart was more than justified by his responses to a series of at least nine interrogations in the Corte Savella and Tor di Nona prisons. He answered with a cocksure mixture of contempt and manic disinformation. At times he crudely reminded the interrogators of his high-status work on important paintings for the Pope's family: '... works that I have for His Holiness and the Most Illustrious Cardinal Borghese.'

At other times he seemed almost demonic in his capacity to mirror and reverse what other witnesses had said. In his version of the encounter at St John Lateran, for instance, it was two other men

who followed Artemisia. He even, from a distance, watched them buy doughnuts for Francesco. Stiattesi, he said, had confessed to him that he was screwing Artemisia and that he, Stiattesi, took pride in deflowering young women wherever he went. Guessing – or having intelligence about – what others had said, he outrageously upended it all in a surreal and sleazy cloud of counter-accusations. The intention didn't seem so much to prove his innocence as to spread the dirt around until no one could be sure what was truth and what was a lie. He even managed, from behind bars, to have Stiattesi thrown briefly into prison for debt.

Ultimately his defence came down to a crude enough attempt to portray Artemisia as a whore. He claimed it was Orazio's anxieties about her character that led him, Agostino, to take an interest in her welfare:

> The said Orazio opened up about his feelings and told me that when he said his daughter was living a bad life (*cattiva vita*) he meant she was a whore (*puttana*) and that he didn't know what to do about it.

He also claimed Orazio and Stiattesi were hounding him because they both owed him money and were trying to avoid paying him back. And he claimed he first went to the Gentileschi home when Orazio was out because he was asked to teach Artemisia – 'I went to the house of Orazio in his absence because he sent me there, because he wanted me to teach his daughter perspective...'

Tassi did not make much of it, and it was only later repeated by his most transparently and feebly corrupt defence witness, a boy called Nicolò. And why didn't Tuzia mention it? Tassi stated this on 6 April, but by 8 April he was claiming instead that Gentileschi sought his help in handling a 'whore' of a daughter. The simplest explanation is

surely that the perspective lessons were another insidious fabrication by the highly inventive Tassi.

And so Tassi continued, day after day, with his own accusations and tales. The inquisitorial process was supposed to break defendants and witnesses. Tassi just seemed to flow on imperviously, admitting nothing, filling the judges' ears with counter-gossip. He didn't miss a beat when they asked him about the death of his wife in Tuscany. Stiattesi said she was murdered at Tassi's behest. Tassi admitted celebrating her death – but said it was because she'd betrayed him, not because he'd had a hand in it. Yet just before this, he'd claimed he had no idea if she was living or dead. Between the two contradictory claims he was surely trying to second-guess what the judges knew and didn't know. He could have gone on forever.

On 8 April Cosimo Quorli died. His position in the papal household had protected him from arrest and interrogation, although the more conspiratorially minded might think his death conveniently spared the papacy considerable embarrassment. He died without being asked to explain himself.

Around 1 May, at Tassi's request, Stiattesi made a last-ditch attempt at a solution, and the one he thought best was the reconciliation of 'the lovers' and their marriage. He arranged a night-time outing to the Corte Savella – behind Orazio's back. Stiattesi was clearly taking upon himself a quasi-parental role, and expressing serious doubts about poor old Orazio's judgement. Orazio was told they were going to San Carlo ai Catinari – one of the new Roman churches – and Artemisia, her brother Giulio, Stiattesi, his wife Porzia and their son Luisio set out.

Before this gathering, Tassi promised to marry Artemisia, on one small condition: that she swear that someone else had taken her virginity. He helpfully suggested candidates, including the lately deceased Quorli.

Another witness to this scene was Father Pietro Giordano, who saw it all in a more glorious light. Artemisia had expressed love towards Tassi, while Tassi had described her as his wife. According to Giordano their pledges, in front of a priest, were literally a form of matrimony.

Two weeks later Artemisia went again to the Corte Savella. Here she was to undergo another 'ceremony', which she would see as a cruel parody of the marriage that had not materialized. On 14 May 1612, the Curia brought Artemisia to Tassi's prison. There, she was asked again to repeat her rape charge to his face. He denied it and called her a liar. Would she, asked the judges, 'ratify' her story 'even if tortured'? She declared, 'My lord I am ready to confirm my statement under torture and whatever must be done.'

So the judges ordered her to be subjected to the torture of the *sibille* (named for the truth-telling ancient prophetesses, the sibyls) 'to remove all infamy or doubt about her person or words'. It was to be done, 'Recognising that this woman, as can be seen by looking at her, is seventeen years old.' (Artemisia was now 18 years old.)

The aim of torture was to release the truth from a suffering body and so bypass the mind's cunning. It was an instrument of mental terror as well as physical pain. Galileo Galilei, 15 years later, would be so afraid of the threat of torture by the Roman Inquisition that he recanted his defence of Copernican cosmology. In a judicial context, torture was most useful for those inclined to lie and most identified with their physical selves. Artemisia's torture was voluntary, but the clear implication was that to take the word of a young lower-class woman against a man's would be reckless without it.

In the *sibille*, cords were wrapped around Artemisia's fingers, then pulled tighter and tighter to gradually crush them. Before the cords were applied, but with a clear view of what she was in for, Artemisia once again insisted, 'I have told the truth and always will, because it is true, and I will do what is needed to confirm it.'

The judge then ordered the torture to go ahead. The guard applied the *sibille* so both of her hands were in front of her chest and the cords could be tightened on all her fingers. Then it began, with Tassi watching.

As the guard tightened the *sibille*, Artemisia declared, 'It is true it is true it is true it is true (é vero é vero é vero é vero)'. You can hear something like awe in the notary's words as he continues in the report, 'repeating the same words again and again...'

Then, as the circular bonds continued to crush her fingers, Artemisia spoke to Tassi directly: 'This is the ring you gave me and these are your promises.'

Asked once again whether what she had said was true, Artemisia replied, 'é vero é vero é vero, everything that I have said.'

'It is not true, you're lying in your throat,' Tassi protested.

'It is true it is true it is true,' Artemisia replied.

Artemisia embraced her torture like the female saints she had been brought up to emulate. But the 'faith' she was witness to and suffering for was faith in herself. And she was not being persecuted by pagan Romans but by Christians of the Counter-Reformation.

The judge ordered the end of the torture. After the cords were untied, Artemisia recited a Miserere, the prayer of repentance that David made after sleeping with Bathsheba. In the Book of Common Prayer it begins:

> Have mercy upon me, O God, after Thy great goodness
> According to the multitude of Thy mercies do away mine
> offences.
> Wash me thoroughly from my wickedness: and cleanse me
> from my sin.
> For I acknowledge my faults: and my sin is ever before me.
> Against Thee only have I sinned, and done this evil in thy

sight: that Thou mightest be justified in Thy saying, and
clear when Thou art judged.

Behold, I was shapen in wickedness: and in sin hath my
mother conceived me.

But lo, Thou requirest truth in the inward parts: and shalt
make me to understand wisdom secretly.

Thou shalt purge me with hyssop, and I shall be clean:
Thou shalt wash me, and I shall be whiter than snow.

Thou shalt make me hear of joy and gladness: that the
bones which Thou hast broken may rejoice.

'That the bones which Thou hast broken may rejoice.' This must
have been an unexpectedly graceful moment in what was shaping
up as a truly base drama.

Artemisia was told to go, but Tassi said he had some questions
written down for her that the judge agreed to ask. They included one
about her relationship with a man called Artigenio – she painted a
portrait of his beloved; with Francesco Scarpellino – she was never
alone with him; with Pasquino – she last saw him when she was seven.
Then Tassi hit harder. Why didn't she tell sooner? Artemisia admitted
that she had told Stiattesi in December 1611 and alternative plans
had been made – probably Stiattesi's efforts to get Tassi to marry
Artemisia. Were you hoping to have me as a husband? Yes, until
two or three days ago, when she learnt that Tassi already had a wife.

This wife was almost certainly not Maria Cannodoli, done
away with, possibly in Lucca, beyond the jurisdiction of the Roman
courts, but Costanza, his sister-in-law, who had been so friendly
to Artemisia. He couldn't simply cast her off because he would be
haunted by the threat of incest charges. So this was Tassi's labyrinth.

By late May Tassi was officially allowed access to the interrogation
transcripts and could produce witnesses of his own. He managed

to round up a few lowlifes who would lift a rock on a squirming world of male sexual paranoia, or perhaps just Tassi's fantasies, for some witnesses were certainly tampered with. A youth named Giuliano Formicino testified that he had heard from Stiattesi that Artemisia had lost her virginity to Pasquino from Florence. Luca Penti, a tailor, had also heard that Artemisia had had sex with Pasquino and Quorli, and that Stiattesi had called her a whore. He had also seen her at a window – behaviour typical of a courtesan. Marcantonio Coppino, a mixer of ultramarine, was forced to testify, but he had heard that Artemisia had slept with many men. He had also heard in the paint shop and at Angelo the sculptor's that she posed nude for Orazio and that people came to watch. Most committed was a boy called Nicolò Bedino who claimed – in spite of evidence to the contrary – that he had been Orazio's apprentice at his last three addresses and had witnessed Artemisia's shameless behaviour with numerous men and been forced to quit because he was sick of delivering the (illiterate) Artemisia's love letters.

Orazio must have been devastated by the mud being slung. It was now that he wrote to Christina of Lorraine advertising his daughter's genius, yet his letter is full of rage and fear. Orazio beseeched Christina to intervene. He was concerned that Tassi, who had formerly worked for Christina's late husband Ferdinando I, had been receiving help from the Tuscan court, so 'confident in the goodness and mercy of your Serene Highness I resolved to inform you of this arch crime, at last desiring, in accordance with your noble nature, that justice should not be muffled and hushed up'. This, he hoped, she could bring about not only by getting her people to stop assisting Tassi but by 'addressing a letter to Signor Cardinal Borghese, pleading that he instruct that in this cause justice is meted out and that he who has erred is punished'.

Soon after writing this letter Orazio brought new charges against Tassi and four of his witnesses for slander, which included Tassi's accusation that his dead wife Prudentia was also a whore. So overwrought was Orazio that in the new charges he mistakenly described Artemisia as 15 at the time of the rape. The case had become a scandal. An attempt to defend the family honour by prosecuting Tassi had resulted in its being horribly besmirched by a rapist's bottomless capacity for deceit.

It must now have been widely disseminated that Artemisia was not a virgin. She was sexually anomalous according to the mindset of her world. She could not remain respectable and unmarried. Nor could she remain in Rome. So the ever-helpful Stiattesi stepped in with a suggestion: why should Artemisia not marry his younger brother, who lived in Florence?

A contract (which recently came to light) was drawn up on 11 August 1612 for the agreed marriage between Artemisia and Pierantonio di Vincenzo Stiattesi, citizen of Florence, the son of a tailor. Pierantonio is described as *spetiale*, an apothecary, or literally a spice-dealer, someone who traded in medicines but also more germanely in pigments.

The negotiations, which included crucially the provision of a dowry, were carried out by Orazio and Giovanni Battista Stiattesi; Pierantonio, residing in Florence, was absent. Orazio offered a dowry of 1,000 gold scudi – the Florentine conversion rate is also quoted – to be paid in instalments. The dowry was either to be placed in a bank (the Monte della Pietà di Fiorenza), with Pierantonio having the option to borrow the principal to provide a house and furnishings, or to be used to open an apothecary or another specialist workshop, specifically with Artemisia's permission. Twenty scudi were to be provided for a trousseau. Orazio anticipated her becoming a Florentine citizen, 'as if she had been born in Florence'.

A week after the contract was drawn up it was taken to Florence for Pierantonio to sign. Artemisia had almost certainly never met him. The contract specified that she must take him willingly according to the disposition of the Holy Council of Trent and other Pontifical Constitutions and in the manner demanded by the Holy Mother Apostolic Roman Church. Not the most romantic phraseology. But she may not have been averse to the deal being offered. The marriage contract specified that she should have the last word on how the dowry was used; the advancement of her painting career was an obvious option and one that we can assume Orazio anticipated. An opportunity now opened up for her to go to a city where the streets were lined with masterpieces by Donatello, Michelangelo, Cellini and Giambologna.

A husband was a necessary adjunct, to be a guarantor for contracts, to enable her to purchase artistic supplies, to make her respectable. This is what Pierantonio, who was nine years her senior, was – and little else; in her letters Artemisia can't even bring herself to use his name, he is always 'my husband'. His job description as an apothecary seems to have been fanciful; in a legal document a decade later he is described as a painter and there is no evidence he was that either.

The trial, including the additional slander charges, staggered on into the autumn. Tassi's creature Nicolò Bedino ended up being tortured with the *strappado*, in which the victim was suspended by their hands tied behind their back, resulting in the dislocation of the shoulders. Nicolò remained loyal to Tassi so he must have been pretty scared of him – or devoted.

On 27 November 1612 Tassi was found guilty of rape of a virgin – *stuprum* – and the suborning of witnesses. He was offered a choice between five years on the galleys – which tended to prove a death sentence – and exile from Rome. He chose exile. The following day the

sentence was reformulated as five years' exile. But it was not enforced. The following year a simmering dispute with a lodger brought this lackadaisical state of affairs into the open. Tassi's sentence was extended to exile from all Papal States, but the next day this was formally overturned. Tassi was granted a pardon.

Tassi wisely absented himself from the Papal city for a few years to work on a villa belonging to a Cardinal Montalto. On his return he would work with other artists, including the trenchant Catholic visionary Guercino, to paint Rome's walls and ceilings. The great French landscape artist Claude started his career in Rome as Tassi's pupil and servant. He was, in short, more prized by the Pope and his cardinal nephew than Orazio was. And as his star continued to shine through all the disgrace, that of Orazio waned. Eventually Orazio would be forced to leave Rome in search of opportunities elsewhere.

Pierantonio and Artemisia were married in her local church of Santo Spirito in Sassia on 29 November 1612. By early January they made the journey north to Florence, where their marriage contract was deposited with officials on 11 January 1613. It was a new start, at least, and in a city synonymous with artistic fame.

3

Cleopatra

Her face is focused in sharp attention. Keen eyes look into the dark. She is ready, alert, with the sword she took from Holofernes slung over her shoulder, ready for anything, its jewelled pommel clasped in her right hand. Judith has killed her enemy but she can't relax yet. Anything could come out of this inky night. Her servant too looks back. Have they heard a twig break, a rustle, a footstep? Even though Abra has the grisly head of Holofernes in her basket, it's not that horror but the electricity of their fine-tuned alertness that makes this one of Artemisia Gentileschi's most gripping works.

Judith and Her Maidservant hangs in the Pitti Palace, Florence, among masterpieces by such Renaissance giants as Raphael, Filippo Lippi and Pontormo. Like these works, it has been in the city for many centuries. Not only does it still hang among other art treasures formerly owned by the Grand Dukes of Tuscany, but it has Florentine art painted into its very being. This painting, perhaps begun as soon as the year of her arrival in Florence, reveals what caught Artemisia's eye there.

The clue is in Judith's attentive gaze to her left. Keeping her chest facing towards us, she turns her head to look off to the side, her eyes bright, steady and clear. She is commanding and in command of herself. It is the look of a hero.

There is no doubting which powerfully masculine Florentine hero this painting transforms into a woman. Judith's tensely perceptive gaze over her shoulder emulates the stony glare of Michelangelo's

David, that colossal statue carved in the workshop of Florence Cathedral at the beginning of the sixteenth century. Michelangelo's masterpiece is a statue of a gaze. As David stands, naked, preparing to kill the Israelites' enemy Goliath with his slingshot, he turns his head sideways to eye up his target. His huge eyes focus relentlessly on the invisible Goliath. All his being is concentrated in that act of attention. Artemisia had already exhibited a fascination with Michelangelo when she quoted the gesture of his Adam cast out of Paradise in *Susanna and the Elders*. She must have been truly impressed by the *David* when she got to Florence, for her *Judith* in the Pitti Palace is his eagle-eyed twin sister.

She would have beheld the nude *David* in 1613 outside the main gate of the Palazzo Vecchio in the city's old government square, Piazza della Signoria. His towering masculinity was the pièce de résistance of a display of statuary in which male muscles rippled and flexed heroically. Opposite Michelangelo's creation across the palace doorway hulked Baccio Bandinelli's thickset *Hercules*, while in the nearest arch of the soaring gothic Loggia dei Lanzi was Benvenuto Cellini's bronze *Perseus*.

Artemisia may have been drawn to Cellini's *Perseus*, posed on the ornate plinth the goldsmith, sculptor, autobiographer and murderer designed himself, because it shared her own artistic interest in decapitation. Perseus stands nonchalantly with his sword in his lowered right hand, while his left arm holds up the severed head of the snake-haired Medusa that he has just cut off. There are perhaps echoes of Cellini, as well as Michelangelo, in Artemisia's Pitti Palace painting of Judith. In the *Judith Slaying Holofernes* she'd painted in Rome, the heroine wields a straight, simple-looking sword. The weapon her Florentine Judith holds has a more elaborately crafted and intricate handle, reminiscent of the refinement of Cellini. She also wears a brooch in her coiffured hair, while both she and

her servant wear rippling fabrics, laces, gold trim. *Judith and her Maidservant* pulses with the lightning of David's heroic gaze, and yet it is a courtly painting with tasteful dress, hairstyles and jewellery.

The art in Piazza della Signoria told a story of political change. Michelangelo's *David* had been installed as the keen-eyed guardian of the Florentine Republic in 1504. The statues placed around it half a century later were symbols of the absolute rule of the Medici dynasty. It was Cosimo I, from a minor branch of the Medici (and not to be confused with the fifteenth-century founder of the family's greatness, Cosimo the Elder), who turned Tuscany into a Grand Dukedom. He took charge of Florence in 1537, crushed all dissent, and conquered Siena to finalize his ducal ascent.

He was lucky in his artists. Cellini and his rival Giorgio Vasari were not geniuses like Michelangelo, who as a lifelong republican refused ever to return to Cosimo I's Florence. But they combined ingenuity with a strong sense of the history of Florentine art. Both also wrote books. Cellini tells in his memoirs how he cast the *Perseus* for Cosimo. Vasari's efforts for the Medici went further. As a writer, he tells the entire story of the Renaissance through a Florentine filter in his *Lives*, dedicated to Cosimo I. As an architect and painter he reshaped the government palace into a home for the Medici, frescoed with sprawling depictions of their achievements that effaced its republican past. He also built a horseshoe block of offices – the Uffizi – for the Duke's government between the Palazzo Vecchio and the river Arno. And he created a secret passageway above the shops on the Ponte Vecchio so the Medici could move unseen between the cramped 'Old Palace' and the more grandly befitting Pitti Palace on the other side of the Arno.

The courtly atmosphere of the Florence to which Artemisia moved in 1613 can still be felt in the Boboli Gardens that turn the hill behind the Pitti Palace into a magical stage set. From a cavernous

underground pool in the Pitti courtyard to the Grotto with its stucco encrustations, stalactites, grinning satyrs and lovelorn shepherds, these gardens create a classical fantasy world. It goes almost without saying that the earliest surviving opera, Jacopo Peri and Giulio Caccini's *Eurydice*, was performed in 1600 at the Pitti Palace.

The Medici also mounted sea battles on the river Arno and chariot races in the city squares. The atmosphere of ritualized splendour is preserved in the fountains that typify this silver age of Florentine art. Bronze satyrs sport around Bartolommeo Ammannati's Neptune Fountain in Piazza della Signoria, while Giambologna's Oceanus Fountain in the Boboli Gardens brings the sea into the city.

How was an illiterate young painter from Rome whose name had been dragged through the dirt to make her way in a court of such style and sophistication? Artemisia could claim a Tuscan artistic heritage. In Florence she called herself Lomi, not Gentileschi, emphasizing her Tuscan roots and her connection with her locally respected uncle, the painter Aurelio Lomi. And one career obstacle was removed when she learned to read and write. It's possible that she also sang and played music at court operas, a role that was permissible only for non-noble women like her. Artemisia's painting *Saint Cecilia*, probably done before she left Rome, portrays the patron saint of music lost in ecstasy as she strums a lute. In a self-portrait done in Florence in about 1616, she herself plays the lute. This round-bodied stringed instrument had amorous associations. It was what lovers played under women's balconies. Artemisia plays it for herself, her face pummelled by melancholy.

Florence would open Artemisia's eyes to new artistic possibilities. She would move in intellectual and cultured circles, and a substantial number of her paintings would enter the Medici collection. In the meantime she had to cope with the much less glamorous reality of a marriage of convenience that wasn't especially convenient.

Artemisia became pregnant almost as soon as she reached Florence and she gave birth to her son Giovanni Battista in September 1613. He was baptized in Santa Maria Novella, a Gothic masterpiece in the northwest of the city containing a treasure trove of early Renaissance works, including Ghirlandaio's depiction of a new mother and her female helpers in his fresco *The Birth of the Virgin*.

Artemisia would go on to have four more babies in five successive years: Agnola, Prudentia, Cristofano and Lisabella. But Pierantonio never showed any sign of becoming the respectable citizen artisan that Orazio believed he was getting for a son-in-law. Going by their children's baptismal records they moved frequently, eastwards to Santa Croce, southwards to San Niccolò on the other side of the Arno, then back to the northwest of the city. They may possibly have stayed with Pierantonio's kin, who seem to have been abundant. In 1614 Artemisia is recorded as ordering art supplies through the Florentine Academy of Design, the Accademia del Disegno, through which artists themselves regulated their own profession in the city. It was Artemisia's talent that the Stiattesi family would depend on.

Christina of Lorraine seems to have responded to Orazio Gentileschi's overtures and introduced his daughter to the Florentine court. Artemisia's tough artistic style came as a breath of fresh air in ultra-refined Florence. Cosimo I had corralled the arts into propaganda and spectacle. Under his sons Francesco I, who died in 1587, and Ferdinando I, who ruled until 1609, Florence froze into a beautiful but brittle late Renaissance 'Manner' (*Maniera*). The Mannerist style rejected reality and equated art with refined craft. Its opulent delicacies were institutionalized in the Grand Ducal Galleria, where workshops produced everything from multicoloured marble tabletops to costume jewellery. This control and patronage of specialized crafts boosted the economy and anticipated later

initiatives by European rulers, such as Meissen porcelain, sponsored by Augustus the Strong. Yet artistically it was a dead end. It took Artemisia to bring the boldness of the Caravaggisti to Florence.

Ferdinando I had prepared for a religious career, but when his brother died and he unexpectedly became Grand Duke he renounced his cardinalcy to marry Christina of Lorraine. From his death in 1609 their son ruled as Cosimo II. But the young Duke was ailing. Cosimo II's court was controlled by Christina together with his wife, Maria Maddalena of the House of Habsburg. A historian once called it 'woman-ridden'. It's possible the dominance of women in the Pitti Palace made it easier for Artemisia to succeed there. One glimpse of the figure she cut at court is her inclusion in Cristofano Bronzini's book *On the Dignity and Nobility of Women*, written during her stay in Florence. It gives an entirely fictional account of her early years, but one that accurately stresses her allegiance to Caravaggio, whose (non-existent) *Susanna* she is said to have copied.

The power of women features in a haunting Florentine work painted the year Artemisia came to Florence. Cristofano Allori's *Judith and Holofernes* is as personal as hers – but he sees it from a man's point of view and paints this scene of female conquest as an opera of the beautiful and macabre. Allori portrays himself as the severed head of Holofernes, his eyes closed, grasped by his hair by a man-killer who looks out of the night with a dark-eyed disdain. This cruelly seductive Judith is a portrait of Allori's lover Maria di Giovanni Mazzafirri, who was nicknamed La Mazzafirra. Her servant was modelled on La Mazzafirra's mother, adding to the intimate confession that entertained Florence's gossips.

Allori's *Judith* became famous and so did the story behind it. He did other versions. Yet the first and best, which survives in the Royal Collection, is signed and dated 1613. It could be Allori's response to Artemisia's shockingly personal *Judith*.

Allori became one of Artemisia's close friends in Florence and was godfather to her son Cristofano, named for him in November 1616. Perhaps his own autobiographical *Judith* is an interpretation of her radical achievement. Yet for all its eerie charms, Allori's painting is very different from Artemisia's grisly depiction of two women beheading a man. It has a Mannerist delight in painterly subtlety and self-conscious game playing that echoes earlier Florentine puzzle pictures such as Bronzino's *Venus and Cupid*. This conservatism is not surprising, for Allori belonged to a dynasty of Florentine artists that went right back to Bronzino himself.

Artemisia's friendship with Allori gave her access to skills refined in Florence over centuries. The soft gold sheen of Judith's gown in Allori's picture is echoed by the capacious bright yellow skirts of Artemisia's *Penitent Magdalene*, painted in 1617, another of her works that's now in the Pitti Palace. This painting plays Allori's game of self-portraiture and confession. The Magdalene could be Artemisia herself, or it could be a reference to the Grand Duchess Maria Maddalena. The piety of the theme has somehow got lost. Mary Magdalene places her hand on her breast soulfully but the religiosity of the gesture is undermined by the partial exposure of her pale bosom and the way she looks directly at the onlooker. Even in Titian's erotic portrait of a Magdalene whose breasts are covered only by her hair, her rapturous heavenward gaze is holy. Artemisia's Magdalene looks out of the painting inviting a response. It's a painting that replaces prayer with solicitation.

In Artemisia's Florentine art the uncontrolled, perhaps even unconscious autobiography in her first ambitious canvases has become far more self-conscious. In a recently rediscovered work of 1614 to 1615 she pictures herself as Saint Catherine of Alexandria, looking straight out of the painting as she places her hand on the broken wheel with which the pagans tried and failed to kill this

early Christian in Egypt. Artemisia is surely alluding to her own ordeal as a rape survivor who was also tortured. The hand she rests on the spiked wheel has bony knuckles that could have been damaged by her torture. Those same fingers are displayed again and again in her art: the Magdalene has them too. But why is she playing in this conspiratorial way on her brutal experience?

The way Artemisia and Allori play on autobiography in the Florence of Cosimo II translates the conventions of Florentine poetry into art. Ever since Dante told the story of his love for Beatrice, poets in the Tuscan tongue had been publicizing details of their emotional lives. Petrarch invented the sonnet sequence in order to dramatize his lifelong adoration of 'Laura', founding a genre that became meat and drink to Renaissance Florentines. Michelangelo's poems explore passions for men. The poetic self-consciousness of Artemisia's art reveals that a woman who hadn't been able to read at 19 was now, in her twenties, part of a cultivated and literary world. Allori's friends included the playwright Jacopo Cicognini and the poet Ottavio Rinuccini. It also included Michelangelo Buonarroti the Younger, the great nephew of *David*'s creator.

The first letter we have by Artemisia herself was written to Buonarroti on 7 September 1615. She addresses him as 'Magnificent Lord Godfather', and at the end of the letter signs off 'most affectionately, as your daughter'. Clearly this is a relationship of considerable intimacy, and also dependence. For the contents are plain enough: she wishes to borrow 21 lire. There is also a post-script written by her husband Pierantonio, who also addresses Buonarroti as 'godfather'. He too needs to borrow money, but a much larger sum of four or five ducats because his Lordship knows 'how many setbacks I have endured'.

Buonarroti was by now one of Artemisia's keenest supporters in Florence. He wished to create a museum to his great uncle

Michelangelo's memory. This pioneering artistic memorial, still in business today as the Casa Buonarroti in Santa Croce, was to have allegorical paintings of the great Renaissance man's virtues and qualities. So he commissioned Artemisia to paint an allegory of one of those merits, Inclination.

The most obvious reference to the art of Michelangelo in Artemisia's *Allegory of Inclination* is the nudity of her female figure – at least, it was fully nude, before drapery was added in the later seventeenth century on the orders of another descendant, Lionardo Buonarroti, to clean up what's still a joyous constellation of flesh and sky. Yet this astral nude plays a game of cyphers, clues and persons just as enthusiastically as any Tuscan poet or painter that manages to merge Michelangelo's memory with a homage to a living star of the Medici court.

Galileo, although Tuscan by birth, was working at Padua University within the Republic of Venice when he did his most revolutionary scientific work. Yet after he aimed a telescope skyward to look at the moon and other phenomena in 1609, he used the news of the epochal discoveries he made to secure a post at the Florentine court. Cosimo II, to whom he'd given lessons, had just become Grand Duke so Galileo dedicated his 1610 book *The Starry Messenger* to Cosimo and named the moons of Jupiter, described in it for the first time, 'the Medicean Stars'. Cosimo welcomed Galileo to Florence as the court's most glittering star, just as his fame exploded across Europe.

A letter that Artemisia wrote years later to Galileo reminds him of the days when they were friends in Florence. By then her life was focused on hard work and he had just been released by the Inquisition, but when she painted the *Allegory of Inclination* between 1615 and 1616 they were both celebrities at the Medici court. Her allegory is determined to pay him compliments. A star similar to

the pointy celestial shapes he drew in *The Starry Messenger* twinkles in the blue. Inclination holds a compass in a bowl, and turns it on an incline. Not only does the compass suggest Galileo's invention of a 'military compass' but in one of his most famous experiments he rolled objects down inclined planes.

Whether these nods to Galileo were devised by the artist or suggested by Buonarroti the Younger, they reveal how much Artemisia's horizons had expanded by 1615. She received payment for her work in early November; she accepted it in bed as she was giving birth to her third child.

On 19 July 1616, Artemisia Gentileschi became a life member of the Accademia delle Arti del Disegno. She was the first woman ever to achieve this. She'd already been given access to it, enabling her to order artistic materials. Now, however, she attained the enormous prestige of full membership. The friendship of eminent citizens such as Buonarroti, Allori and Galileo must have helped. The fact that her uncle Aurelio Lomi was currently a Consul of the Academy can't have done any harm either.

Founded by Vasari and his fellow artists in 1563 under the patronage of Cosimo I, the Accademia was an astute way of putting Florentine art under Medici control. In return for accepting the Duke's authority, artists were given what they craved – a secure social standing. Vasari's *Lives* is, among other things, the story of how artists rose in status from craft workers to heroic individuals like Michelangelo or princely culture stars like Raphael. The Florentine Accademia, the first institution of its kind anywhere in the world, officially confirmed this rise in status. When Artemisia became the first woman Academician it must have seemed that a stable, solid court career surely lay ahead. Orazio came from Rome to witness her paying her matriculation fee. It may have been a bittersweet moment for him. Earlier that year, on 16 March, the Duke's secretary Andrea

Cioli had written to the Florentine ambassador in Rome, Piero Guicciardini, to ask him about Orazio, as his daughter was now so acclaimed in the city. Guicciardini sent a devastating reply: there was little of Orazio's work to be seen in Rome, he couldn't draw and had a terrible character.

The *Allegory of Inclination* was considered licentious and was bowdlerized. Yet even without draperies it must have looked modest compared with Artemisia's dangerously real depiction of Cleopatra, which may date from her earliest years in Florence. This raw Cleopatra lies on a bed not so different from the one on which her Judith slew Holofernes. With crimson draperies setting off an almost disturbingly real body, this is Artemisia at her most Caravaggesque.

In fact this unconventional Cleopatra was painted by Artemisia in direct response to a particularly perturbing masterpiece by Caravaggio that she saw for the first time in Florence. The ungainliness of her nude, with her legs awkwardly entwined, her flesh mottled and even dirty, and her head thrown back in death's ultimate sleep, is clearly a reference to a painting by Caravaggio that had been in the city since 1609. The fugitive artist painted his *Sleeping Cupid* on Malta, where he briefly became a Knight of Saint John during his final desperate years. It was commissioned by Francesco dell'Antella, a Knight of Malta from Florence, who sent it home to his native city – as was confirmed in a letter in 1609 to Michelangelo Buonarroti the Younger from his brother, also a Maltese Knight.

Caravaggio's *Sleeping Cupid* is still in Florence, in the Pitti Palace. But it hadn't been seen in Rome. It was shipped straight from Malta to Tuscany. Artemisia only encountered this disturbing masterpiece here. Caravaggio's Cupid is naked. His twisted and discoloured body lies in a deathly sleep, his hips are feminine, out of proportion with his head, almost deformed. A big brown belly button prominently pierces his flabby stomach.

Artemisia even echoes the belly button. She had already proved herself Caravaggio's bravest follower. Now, in this subversive reinvention of the female nude, she took the lead from his ugly, ungainly, lumpen Cupid to paint Cleopatra as a non-glamourized naked woman. Her clumsily posed legs echo the twisted hips of Caravaggio's sleeping boy. And where he painted a sleep that looks like death, Cleopatra descends into a death that looks like sleep.

The same model – possibly Artemisia herself, with all the complex use of mirrors and imagination that that required – poses as Danaë, the princess whom Zeus impregnated in the form of a shower of gold. She's on another grand yet earthy bed in a work that looks like Cleopatra's twin. These radical paintings of the human body are intended to scandalize eyes used to the soft allure of Titian's female nudes. Like Caravaggio's crippled Cupid they tear through the veil of art and confront you with the crude fact of physical existence. Artemisia played the courtly game well; Medici inventories reveal she painted lost works for the Duke that include a *Bath of Diana*, a *Rape of Proserpina*, a *Self-Portrait as an Amazon* and a *Hercules*. But Cleopatra reveals she never lost sight of life's pungent pulse. The sheer reality of this nude is an outrage against manners, let alone Mannerism. Her most important artistic encounter in Florence was not with Allori, or Buonarroti. It was her renewed meeting with Caravaggio's ghost.

Artemisia's art was most alive when it was least respectable. That was just as well, for real life kept intruding. In late 1617 her court career and emotional life collided when at the age of 24 she fell in love with Francesco Maria Maringhi, 'natural' son of the noble Niccolò Maringhi, and agent for the Frescobaldi bank. Their relationship has been revealed by the discovery of a batch of her love letters in the Florence State Archive that cast an unsparing light on the last part of her Florentine career, and the reasons it came to a less than dignified end.

Not that having an extra-marital affair was considered sleazy or shameful in late Renaissance Florence. On the contrary, such passion was as much a badge of belonging to the city's cultural elite as enrolment in the Accademia. Love in the Renaissance meant almost by definition an experience outside the hardheaded and practical business of marriage. The idea of courtly love, a romantic, not necessarily consummated, affection outside marriage, was medieval. Yet this ritualized chivalric love took on special intensity in Florence. The medieval Tuscan poems of Dante and Petrarch are addressed to women the poets had no prospect of marrying. In fifteenth-century Florence, Cupid's arrows were still more freely scattered. Not only did the cult of classical poets such as Ovid provide many examples of unruly love but the philosophy of Plato, rediscovered and translated in Florence, offered a language of love that allowed anyone of either sex, married or unmarried, to be its object, while insisting such passions were celibate. 'Platonic love' let Michelangelo send poems and presents to men. It made love affairs outside marriage not only possible but admirable.

Artemisia admits that writing is hard for her, but her letters to Maringhi do sometimes achieve a beauty and finesse. 'May there live in your heart sweet peace, sweet quarrels, dear replies, and finally all the fruits which we have picked in the garden of love', she writes to him on 20 March 1620. But such moments of tranquillity were rare amid a storm raging around Artemisia of personal tragedy, a dysfunctional marriage and debt.

Pierantonio and Artemisia may have behaved extravagantly. Artemisia's first letter to Maringhi is a request for a headdress as a gift for a companion. It's an insight into Florence as a place of temptation and display. To succeed at court you had to dress the part, and in a remarkable monopoly, the Medici themselves produced jewellery and other trinkets at their Galleria that helped you shine;

they feature in Artemisia's paintings, from Judith's cameo brooch to Mary Magdalene's pearl earring. There were also the markets for luxury goods, the Mercantia, as well as the shops for craft goods for which Florentine artisans had been renowned for centuries. But much of the Stiattesis' spending was mundane, on medicines and pigments in a shop on the Carraia bridge, for example. The stumbling block was that the Accademia took a close interest in the solvency of its members. In January 1618 Artemisia was ordered by the Accademia to pay a revised debt for carpentry work. In June 1618 she successfully argued down a ruling of indebtedness on the grounds that she was protected by her membership. Negative rulings would undoubtedly affect her credit and her ability to pursue her profession.

Events may have been lurching out of control. Probably in early 1618 Artemisia sent a message to Maringhi to come and see her before she went to Bologna, a city that had become a significant centre of art. Artemisia must have been considering a decampment, but this did not materialize.

In June 1619 Artemisia petitioned the Grand Duke through an intermediary concerning a debt to a shopkeeper named Michele incurred by her husband. Michele had managed to induce a ruling against her by the Accademia without her knowledge. She considered this unreasonable because her husband controlled all of the dowry. Furthermore, as a woman, with a husband living with her, it was not legal for her to contract a debt. Given the authority we know Artemisia had over the dowry, her approach seems to have been strategic rather than simply washing dirty linen in public.

A few days later her daughter Lisabella died. She was buried in San Pier Maggiore. It seems probable that her two elder children were also now dead. That left just Cristofano and Prudentia. In December, to round off the year, the Accademia ruled that Artemisia must pay a creditor 70 lire.

At some point Francesco Maria Maringhi had arranged accommodation for the Stiattesi family, on Piazza de' Frescobaldi on the southern side of the Arno. It was conveniently close to the Pitti Palace when any bowing and scraping needed to be done. And soon it would need to be done.

On 13 January 1620 Artemisia ordered an ounce and a half of ultramarine for a painting of Hercules from the Guardaroba, which administered the properties and collections of the Grand Duke. A few weeks later, exhausted and depressed, she decided she needed a break in Rome. On 10 February 1620 she wrote to the Grand Duke Cosimo II, giving notice of her plan. Only her signature was an autograph; she must have been anxious about her spelling and grammar in such a formal context. She explains that this withdrawal has been caused 'by the many difficulties I have endured together with the not inconsiderable number of sufferings of my household and family'. She will go to stay 'with my people' (*tra' mei*), with her father and brothers, for two months or so. She assures His Most Serene Highness that she will recompense him for the 50 scudi that she has received on his order – an advance for work she had not yet completed.

But Cosimo II was away in Pisa slowly dying from tuberculosis and Artemisia and her husband had exhausted their credit with his officials, or perhaps one in particular, Bernardo Migliorati. They were barely out of the city gates when they heard that the Guardaroba had seized everything they owned.

Maringhi helped them to improvise a plan. They were to go to Prato to the northwest of Florence and talk to the Podestà – the administrator – whom Maringhi must have known was sympathetic and who would advise them how to negotiate their return. Meanwhile, Cristofano and Prudentia would stay with Maringhi.

On 12 February Pierantonio sent a letter to Maringhi informing him of Artemisia's and his arrival in Prato. There is a postscript in Artemisia's own hand. She addresses Maringhi as 'my love' (*amor mio*), and tells him not to doubt that she recognizes 'the constancy of your love'. Where the affair did resemble the great chaste passions of Dante and Petrarch was its public nature. Yet that ideal is mired in the embarrassing reality that Pierantonio was a complaisant and self-serving cuckold. The letters sent by husband and wife to her lover over the next six months form an extraordinary portrait not of a love affair, for we do not have Maringhi's replies, but of a moribund marriage, almost as if this were an epistolary novel. For reasons of discretion Pierantonio will address Maringhi as 'Francesco Francozzi' and Artemisia will call him and herself 'Fortunio Fortuni', in a triangle of secrecy and intimacy.

Pierantonio gives Maringhi a hair-raising account of their journey on horseback to Prato, along the rugged course of the Bisenzio river. Firstly Artemisia fell off her horse, and then her horse stumbled and she and the horse could have fallen more than 50 *braccia* – 30 metres or so – and been dashed to pieces. But it was worth it, apparently, for Artemisia to learn to ride and demonstrate her fearlessness. He then says pretentiously that if the Grand Duke does not grant him better conditions he will not let Artemisia return, and he would wish her to go to Bologna instead. In a footnote he asks Maringhi to take care of the babies and write to him care of Giuliani Viviani's bookshop. In a footnote Artemisia asks Maringhi to send her husband a hat as he has to meet with the Podestà.

The hat was not necessary. On the same day the Podestà Gino Ginori wrote to Cosimo, confirming that Artemisia had requested permission in the proper manner to leave Florence. He had, however, advised her to return to Florence to finish her work. Artemisia's counter-proposal was to remain in Prato and produce two paintings.

Ginori had also warned Pierantonio he must not remove Artemisia or himself from the State without authorization on penalty of 100 scudi. Pierantonio then told the Podestà that he had in fact hurried back from Pisa to prevent her leaving – a completely superfluous fabrication.

The following day Artemisia wrote to Maringhi asking him to send the children to her in Prato at the first opportunity, and not to expose her paintings. She has no doubt that 'Florence will not see me again', and signs herself, circumspectly perhaps, 'affectionately as your sister'. On 14 February she repeats to Maringhi her disinclination to return to Florence, 'because it seems to me that I do not have any luck (*fortuna*) in this city'. She ponders the option of Bologna again. Maringhi agreed to be the guarantor of the debt to the Guardaroba.

The Stiattesis did not go to Bologna. Within three weeks they were in Rome. On 2 March 1620 Pierantonio sent Maringhi a letter announcing their arrival. There was much snow on the route but they bore it joyfully. They seem, from a later reference, to have been accompanied at least part of the way by Artemisia's brother Giulio, although Pierantonio mentions they chose not to stop in at his father-in-law's. They were now installed at a beautiful house near to the Chiesa Nuova, to the west of Piazza Navona, which had been prepared for them 'as minimally as possible'. Pierantonio adds, 'Now we are waiting for the crate and straightaway the painting for the Grand Duke will be finished.' He also has a startling piece of news: 'It is not true that Agostino Tassi is in prison'.

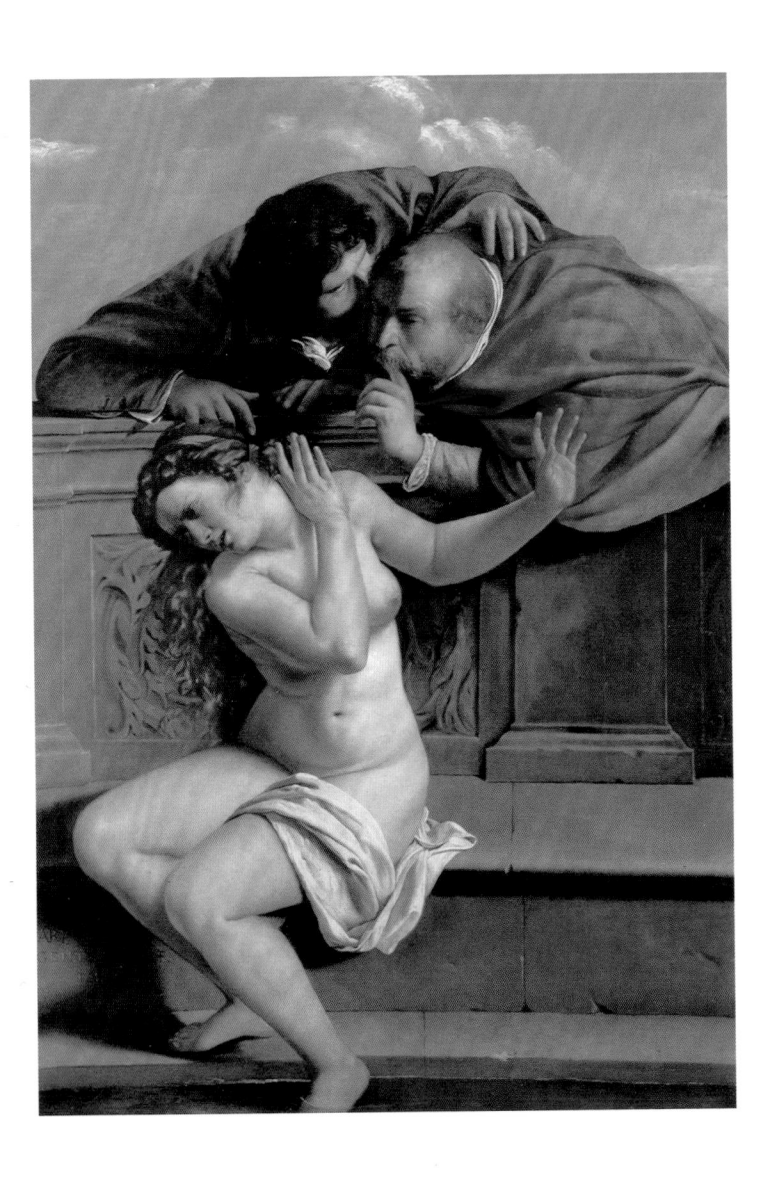

Artemisia Gentileschi, *Susanna and the Elders*, c. 1610,
Schloss Weissenstein, Pommersfelden, Germany

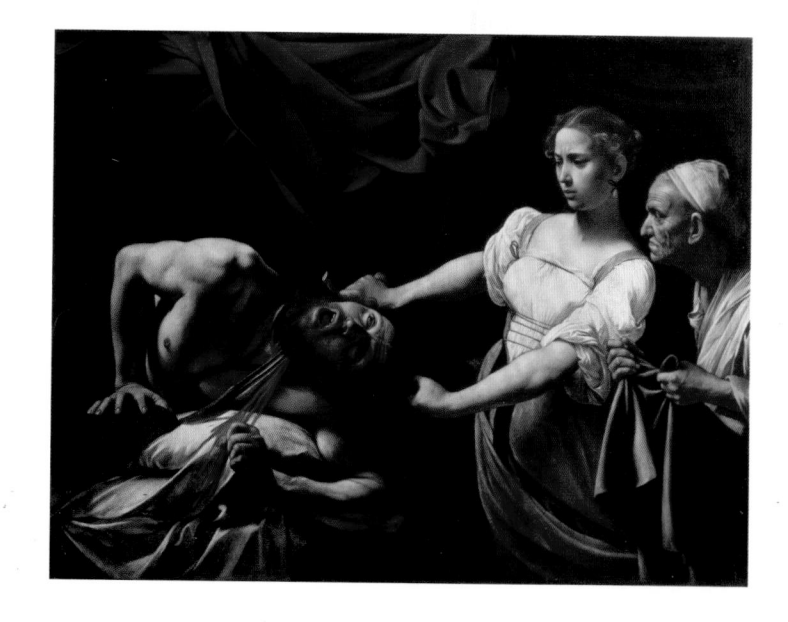

Michelangelo Merisi da Caravaggio, *Judith Beheading Holofernes*, c. 1599,
Palazzo Barberini, Rome, Italy

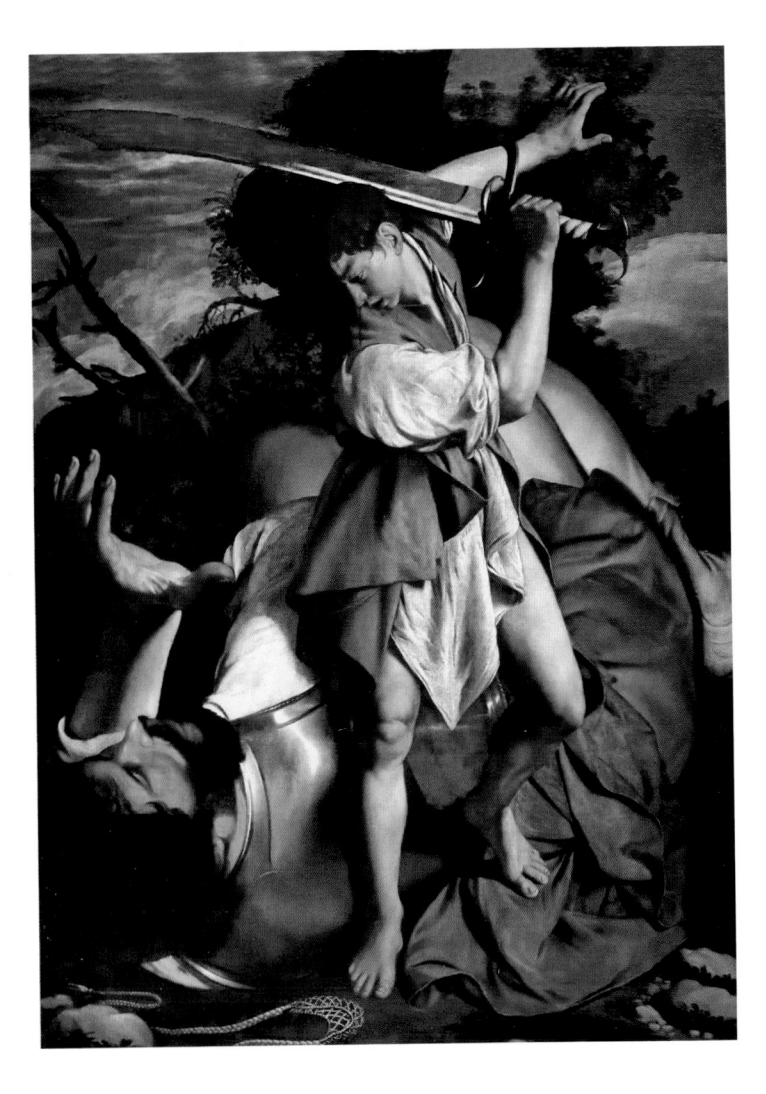

Orazio Gentileschi, *David and Goliath*, c. 1605–1607,
National Gallery of Ireland, Dublin, Ireland

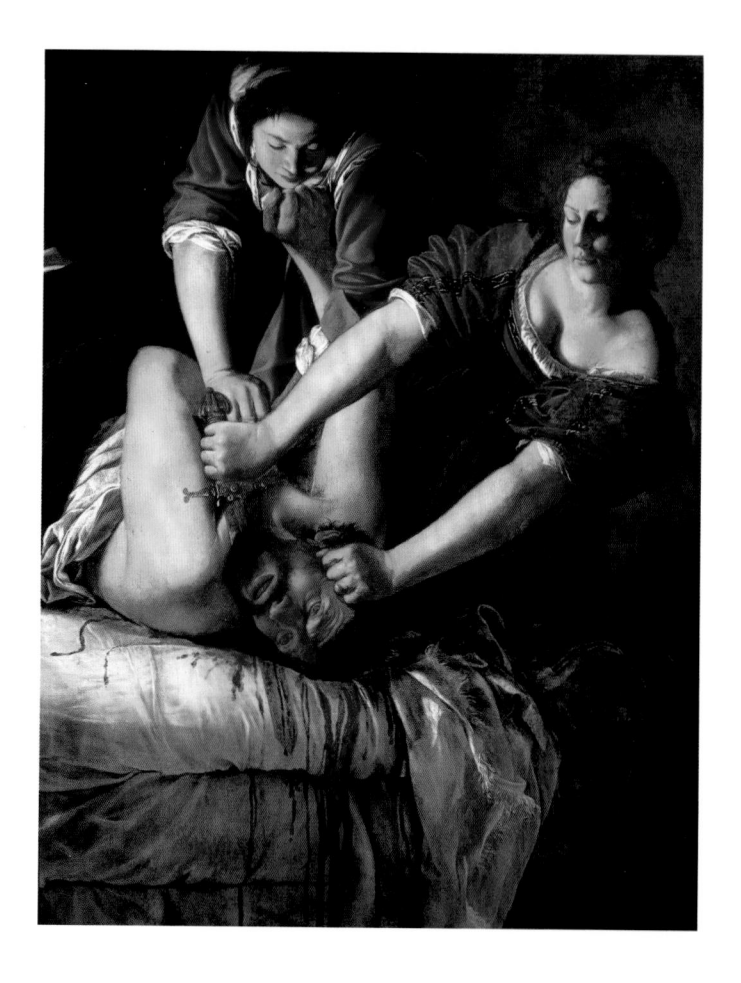

Artemisia Gentileschi, *Judith Beheading Holofernes,*
c. 1612–13, Capodimonte Museum, Naples, Italy

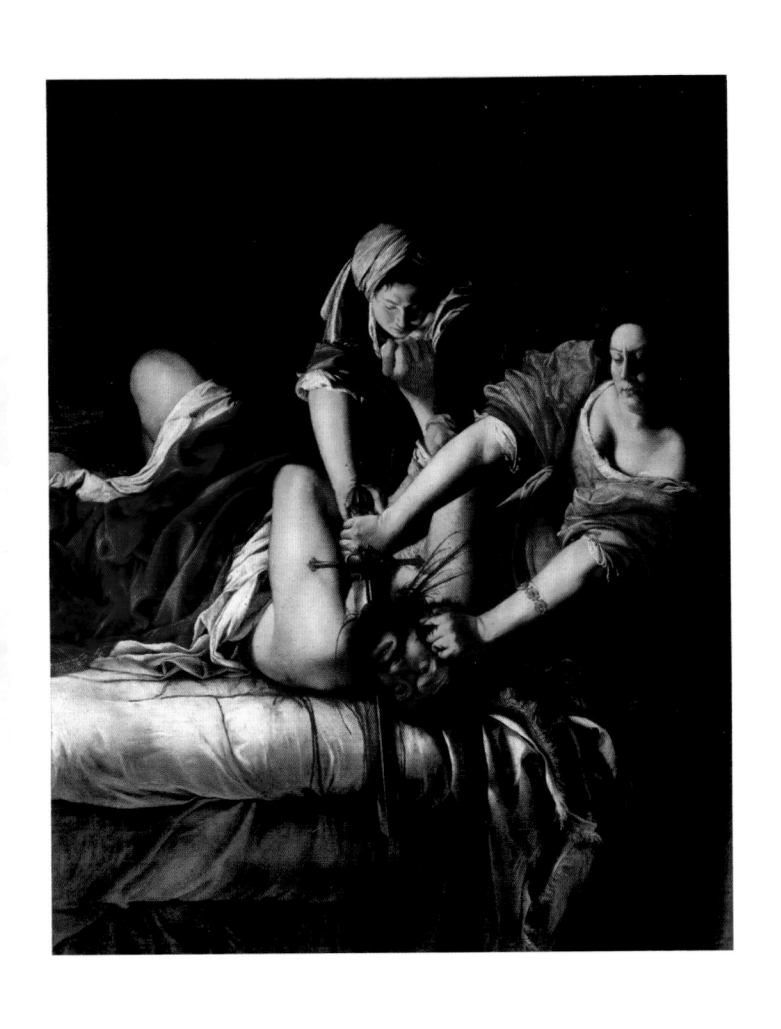

Artemisia Gentileschi, *Judith Beheading Holofernes,*
c. 1620, Uffizi Gallery, Florence, Italy

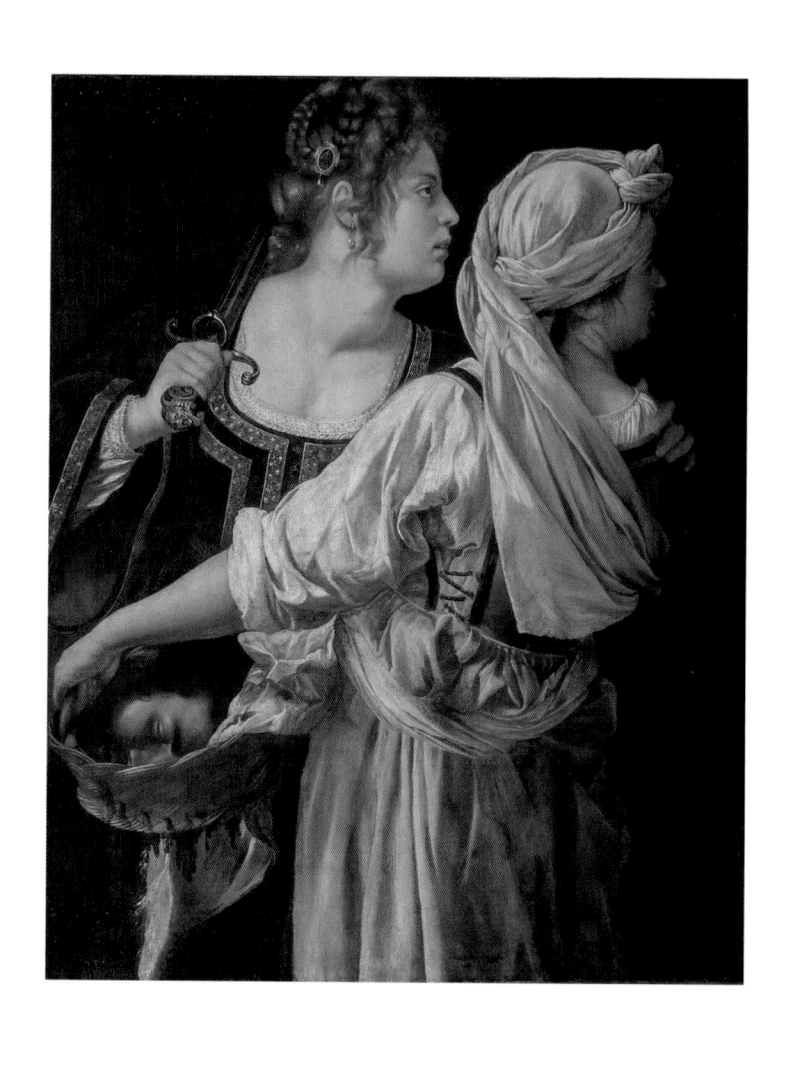

Artemisia Gentileschi, *Judith and Her Servant,*
c. 1616–1618, Pitti Palace, Florence, Italy

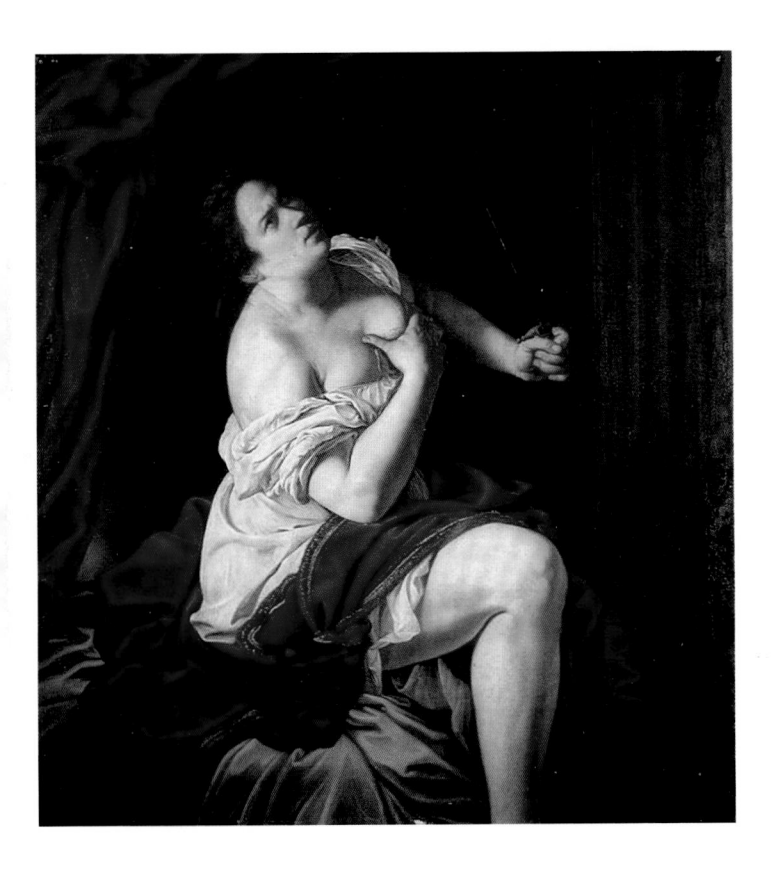

Artemisia Gentileschi, *Lucretia,*
c. 1621, Private Collection, Italy

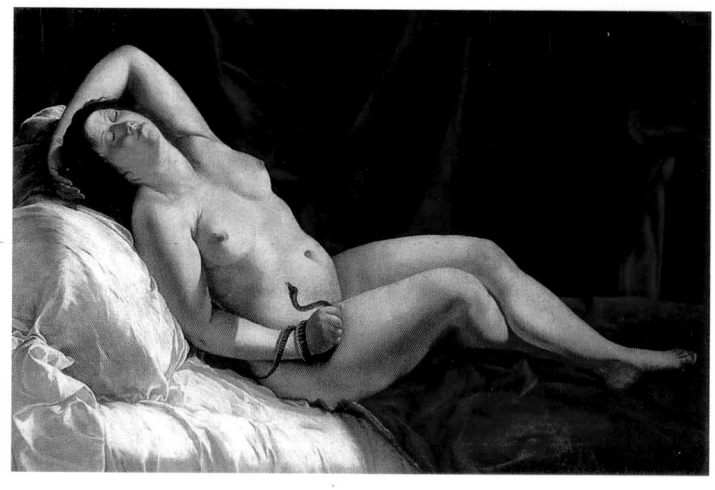

TOP – Artemisia Gentileschi, *Jael and Sisera*,
1620, Museum of Fine Arts, Budapest, Hungary
ABOVE – Artemisia Gentileschi, *Cleopatra*,
c. 1613, Amedeo Morandotti Collection, Milan, Italy

TOP – Artemisia Gentileschi, *Self-Portrait as St. Catherine of Alexandria,*
c. 1615–1617, National Gallery, London, United Kingdom
ABOVE – Artemisia Gentileschi, *Allegory of Inclination,*
1615–1616, Casa Buonarroti, Florence, Italy

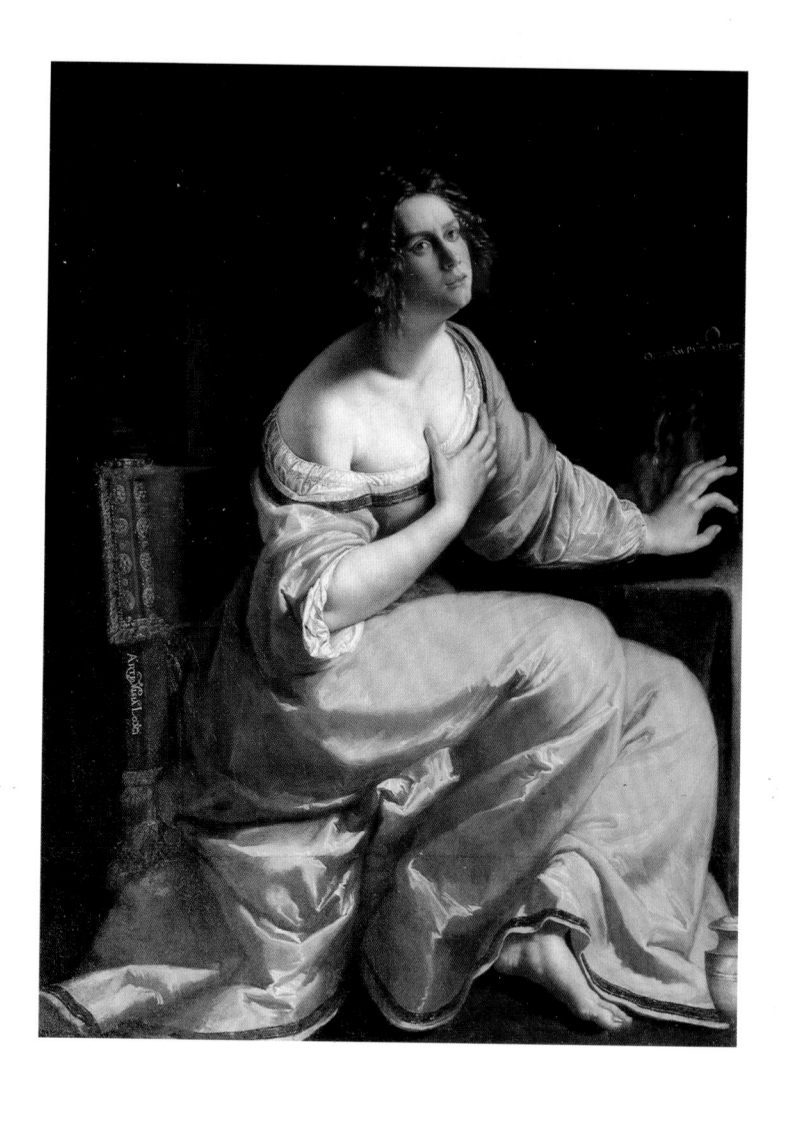

Artemisia Gentileschi, *Mary Magdalene,*
c. 1617–1619, Pitti Palace, Florence, Italy

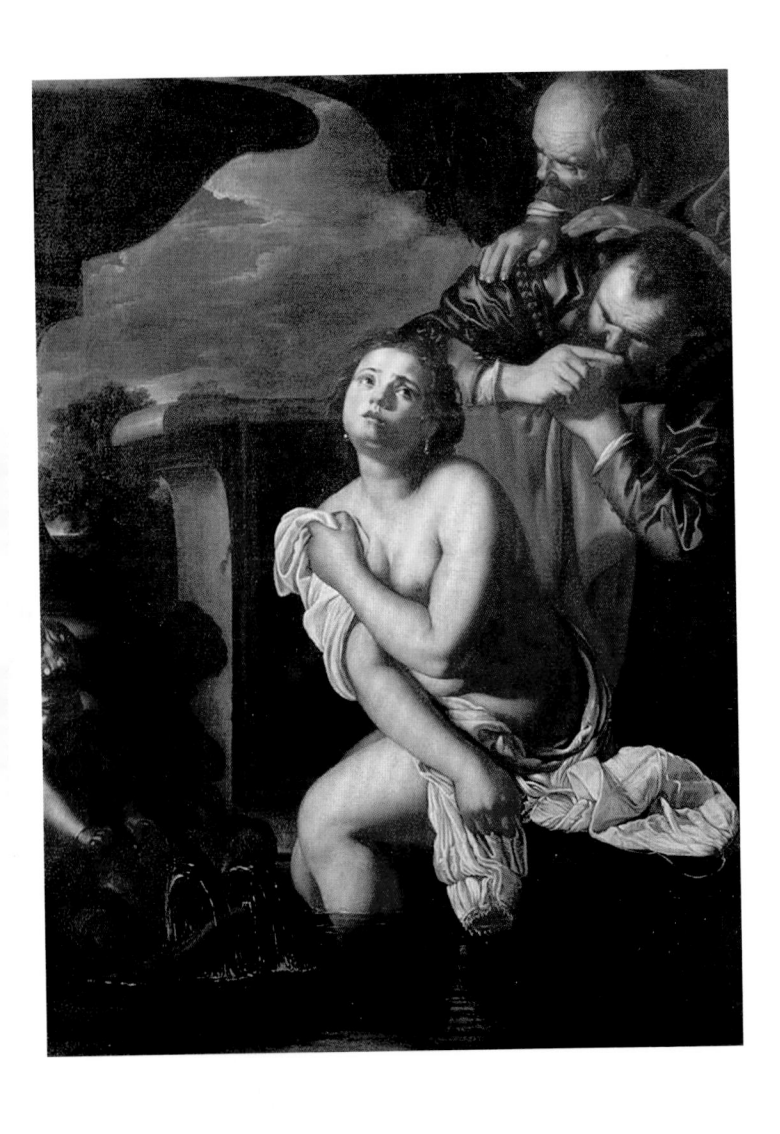

Artemisia Gentileschi, *Susanna and the Elders,*
1622, Burghley Collection, Burghley House, Peterborough, United Kingdom

LEFT – Pierre Dumonstier II, *Right Hand of Artemisia Gentileschi,* 1625, British Museum, London, United Kingdom

BELOW – Artemisia Gentileschi, *Corisca and the Satyr,* c. 1633–1634, Private Collection

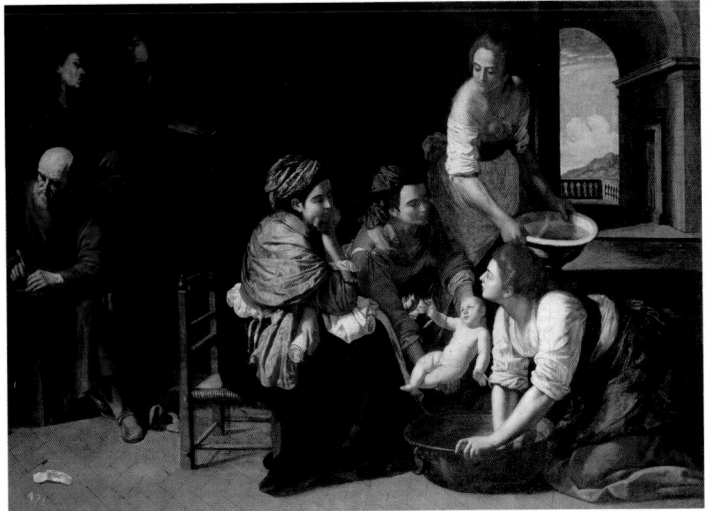

ABOVE – Artemisia Gentileschi, *The Birth of John the Baptist,* c. 1635, Prado Museum, Madrid, Spain

LEFT – Artemisia Gentileschi, *Saint Januarius in the Amphitheatre at Pozzuoli,* 1636–1637, Capodimonte Museum, Naples, Italy

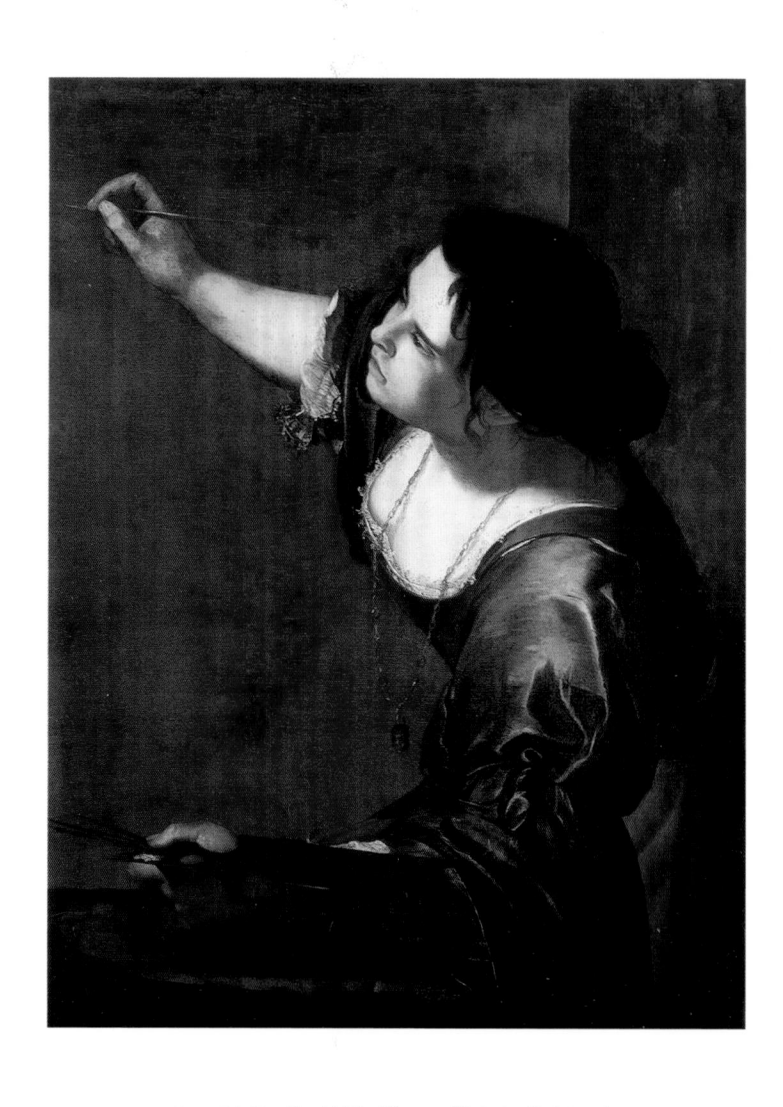

Artemisia Gentileschi, *The Allegory of Painting* (*La Pittura*),
c. 1638–1639, Royal Collection, Hampton Court, United Kingdom

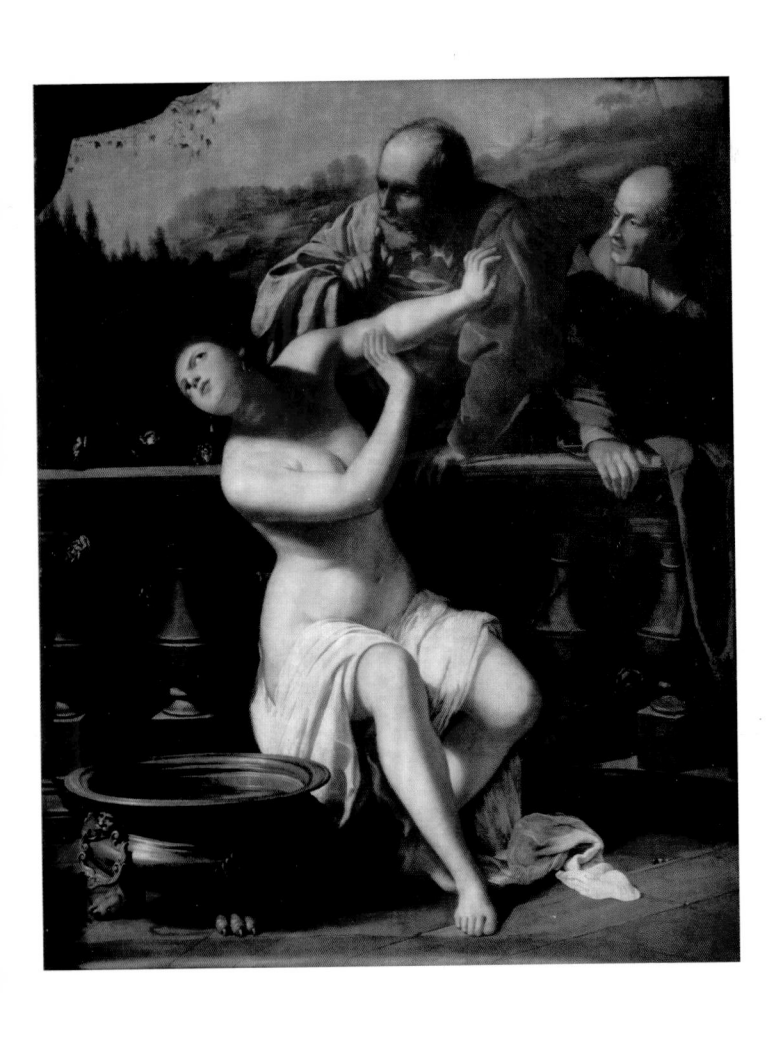

Artemisia Gentileschi, *Susanna and the Elders,*
1649, Moravian Gallery, Brno, Czech Republic

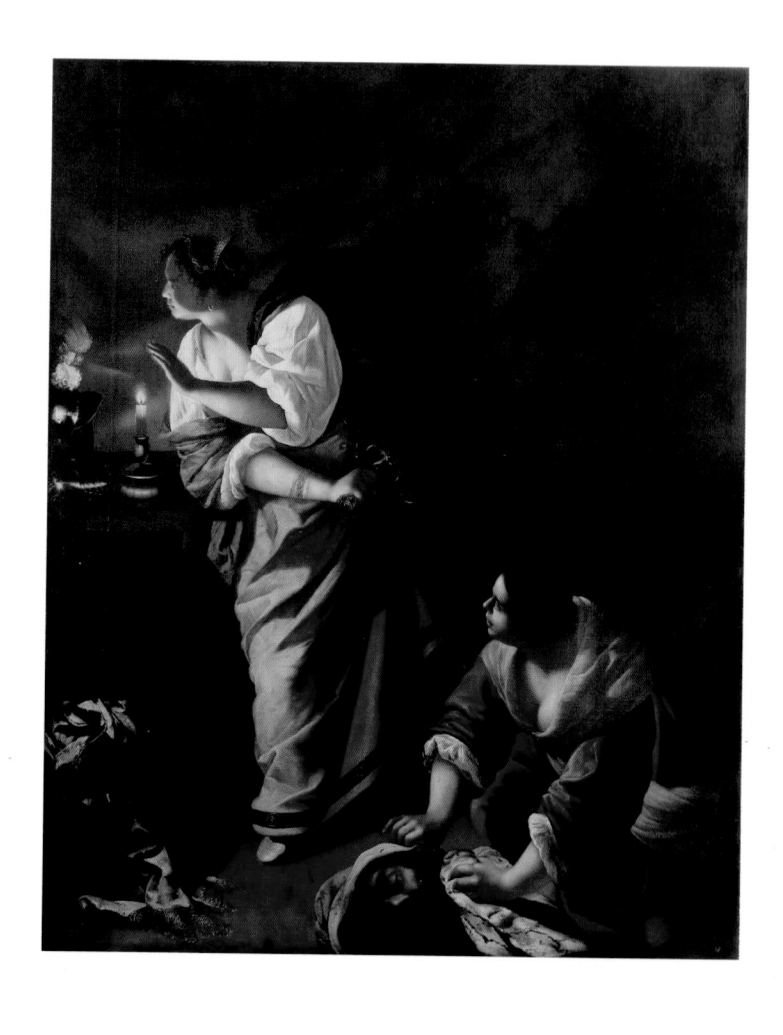

Artemisia Gentileschi, *Judith and Her Servant,*
c. 1645–1650, Capodimonte Museum, Naples, Italy

4

Lucretia

In 1635 Artemisia Gentileschi reminded Galileo Galilei of how he had once championed 'that painting of Judith, that I gave to the Most Serene Grand Duke Cosimo of glorious memory, that would have been lost to memory if it had not been revived by Your Lordship's protection...'

It seems likely that the reason it nearly got forgotten was that it reached the Pitti Palace when Cosimo was dying. Galileo had the full support of his successor Ferdinando II after Cosimo's death in February 1621, so he was perfectly placed to defend this painting in the transition between rulers. In other words, it was almost certainly the painting Artemisia did in Rome in 1620 for the Medici court.

It hangs today in the Uffizi Gallery in Florence, close to Caravaggio's *Medusa*. It might sound familiar: two young women are killing a mighty man. As Judith saws into his throat with his own sword, his eyes are open. He knows what is being done to him. But the servant Abra is on top of him, pinning him down on the white-sheeted mattress as his blood pours out... except in Artemisia's second and greatest version of her most extreme composition, the blood does not just flow. It spurts. A wine-dark effulgence of arterial blood rockets into the air as a series of cascading arcs, in a precise observation of pressurized fluid escaping. Perhaps she had been observing slaughter in a butcher's shop. Holofernes' death was furiously real in the first raw version of this painting that she did as an abused teenager. In her 1620 remake she brings

all she has learned to a picture that is even more real, authoritative and merciless.

There's a monstrous joy to that eruption of gore. The soaring fireworks of blood rising from Holofernes' neck are not like anything Caravaggio painted. His flows of blood were always rivers and pools, including the lake of blood that forms into his signature in his *Beheading of John the Baptist*. Perversely and brilliantly, Artemisia here uncorks the fizzing energy and dynamic ebullience of the Baroque spirit that was transforming her Rome. The age of Gianlorenzo Bernini was beginning. Between 1622 and 1625 this genius of unbounded motion and fluidity would carve his revolutionary sculpture *Apollo and Daphne* for Scipione Borghese, depicting in stone the transformation of a woman into a tree, which seems to metamorphosize as you look. Bernini would eventually design Rome's most flamboyant fountains, but Artemisia was ahead of him in exploring the beauty of rising and falling liquid. The difference is that her Baroque fountain is made of blood instead of water.

While Pierantonio was reporting that Tassi was at large, Artemisia was once again painting the righteous punishment of a male tyrant. She may even have called upon physics to ensure Holofernes died in the most truthful way possible. The arcs of blood coming from him resemble, it has been observed, drawings of the parabolas of projectiles by Galileo. Can it be coincidence that Artemisia painted ariel curves that are so similar to one of her friend's most important scientific observations? Or had he shown her what the parabola of a projectile looked like? Even before Galileo, arcs of artillery fire had been convincingly drawn by Leonardo da Vinci. The study of ballistics, which led Leonardo and Galileo to their insights, was both a scientific and military problem. Parabolas traced the lines of fire that blasted living troops. Artemisia brings this art of war into the bedroom, painting a battle on a bed. Like any

seventeenth-century battle, it features whizzing arcs of cannon shot that burn in the black night.

This conflation of a public act of war with a private nocturnal drama is what makes the Uffizi's *Judith and Holofernes* such a masterpiece. Tragic theatre in the early seventeenth century also put bedroom horrors in the public eye: Othello suffocating Desdemona, Cleopatra putting a snake to her breast. In *Judith and Holofernes*, claustrophobic walls of darkness in a small room isolate the bed on which Holofernes is watching himself die. This raft of linen is thrust forward to the front of the circumscribed space. The side of the bed falls like a cliff in the extreme foreground, with streams of crimson trickling along its furrows. Artemisia doesn't stop looking carefully at the behaviour of the blood once it lands but observes how it follows the paths of least resistance into crevices and crannies of cloth.

It would have been all but impossible for seventeenth-century dramatists to light a scene as she illuminates *Judith and Holofernes*; a candlelit theatre couldn't focus its flames like this. Of all Caravaggio's innovations, the contrivance of light entering a dark room to pick out and isolate bodies and action was the most widely emulated in seventeenth-century art. Through the northern artists who took it from Rome to France and the Netherlands, it would haunt candlelit nocturnes for decades to come. Yet the lighting of *Judith and Holofernes* is uniquely authoritative. It shows how much better than most of his followers Artemisia understood Caravaggio. She ruthlessly casts an intense steady beam on the bed to pick out the exposed arm and leg of Holofernes in random glimpses of fleshy reality. It then catches the intent face of Abra, the meaty arms of Judith as she does her awful work, and finally her breasts and recoiling expression as she leans back to the far right of the canvas. In a dazzling allusion to the gilded court life of Florence she had discovered – and lost – it also glints off a magnificently bejewelled gold bracelet on Judith's left arm.

The light comes from the left-hand side of the painting and it doesn't just illuminate. It darkens. For every bright spot there's a shadow. Darkness defines the tubular arms of Judith and swarms the far side of her face. The face of her accomplice is divided in two by gold and blackness. It's possible to imagine that Artemisia looked through a telescope when she was in Florence, for the division of Abra's face, as the art historian Mary Garrard has pointed out, is as sharply contrasted as a half-visible moon. Galileo provided the Tuscan court with telescopes. He also published engravings of the moon raked by light and shadow in his 1610 book *The Starry Messenger*. Yet there's nothing gratuitously speculative about Artemisia's light. Whatever encounters with astronomy might have helped clarify her understanding of Caravaggio, this knowledge is deployed with a rock-steady purpose: to maximize this moment, to make it penetrate the mind as a moonbeam enters a midnight room. This chamber is not just in front of us but in our skull.

The first version of *Judith and Holofernes* was an almost unconscious release of violence. The 1620 version is more like a disclosure. It is astonishing to see in the Uffizi Gallery because it seems we're looking through a window into a murder scene. As disciplined and formal as the last act of a great tragedy, it lifts the curtain to reveal some terrible truth. But for all this rigour it is at the same time a return to the exact same nightmare image. Your own head is the claustrophobic room where this horror is re-enacted, night after night. Or rather, it keeps happening, over and over again, in Artemisia's mind. At the same dead hour of the night that mysterious light flares up and the old horror reveals itself.

Under its steady technical discipline – a work of painting done with the same dedication as Judith's work of murder – this painting has the obsessive power of a trauma revisited. It returns not just to Artemisia's earlier painting but to the experience that provoked it.

She can't let go of her anger, shock, or fantasies of revenge. She is, as an artist, stuck with this moment: for all that's happened since, she can't help returning to the madness of 1612. Her imagination is a camera obscura where the same cruel tableau resurrects itself every time the candle is lit.

In a letter written to Maringhi on 20 March 1620, Artemisia pledges that if certain matters are not rectified she will certainly die 'because I do not know how I can exist if I do not have revenge' (*perché so come io so e non ho vendetta*). The context for this passionate statement is disappointingly trivial: she's still enraged about the Guardaroba seizing her property, and now there are accusations arising out of the stay in Prato. The latter scraped the barrel of black comedy. Artemisia and Pierantonio must have stayed there with his relatives, but if we stretch our minds back we will remember that the Stiattesis were related to the Quorlis. A certain Margherita Quorli had written to Maringhi accusing Artemisia and Pierantonio of robbing their host, her brother. Artemisia says she will pass over this in silence, except to say that Margherita is 'a procuress' (*una roffiana*), 'an idler' (*una poltrona*) with an obscene and common mouth, and a 'whore' – as is her daughter.

Vendetta was a culturally sanctioned right in a society where honour was treasured. Artemisia could not resist exercising the right to heap vitriol on someone who had roundly abused her, equalizing what would otherwise be an intolerable asymmetry. In a letter that Pierantonio writes the same day to Maringhi and that must have been delivered with it, he adds his own insults, because his honour had also been impugned: Margherita is a most notorious procuress, an evil witch (*strega maliarda*) and a go-between for her daughter. Pierantonio has other slights on his mind, too. He has heard that the painter Alessandro Bardelli has claimed a painting that Artemisia did for the Grand Duke is really by him: let him go and dig a ditch,

that would suit his talent more. And meanwhile the scoundrel Bernardo Migliorati of the Guardaroba has written an outrageous and obscene sonnet to Pierantonio's father-in-law, Orazio, together with a vindictive letter. This last insult has driven Artemisia to her bed in fury.

Law set itself against the desire for revenge, but was forced to acknowledge its power. When Tassi was initially sentenced in 1612, he had to swear upon the Bible not to seek revenge upon Orazio or he would be fined 200 scudi. The assumption was that *vendetta* was a natural and often overwhelming force.

When Pierantonio mentioned that Tassi was, to his surprise, not in prison, he had probably heard that the painter was again up on incest charges. This would not be Tassi's last entanglement with the law, either; in 1622 he would be accused of assault and battery upon Cecilia Durantis, whose nickname was Pretty Feet. Nor is this Tassi's only appearance in the letters.

On 27 March, Pierantonio tells Maringhi a curious tale. He says he would appreciate advice about a 'friend' in Rome who has been attacked by two men. One had fired an arquebus at him; this long gun required extensive preparation and could only be used by an assassin lying in wait. The friend was hit but not fatally. The other man had then run after him with a hatchet, from which the friend received a slight blow. On 11 April, Pierantonio feels at liberty to name the man to Maringhi as Tassi, but the incident was nothing, he says; let us receive the news with a good spirit!

The description of the assault feels like an eyewitness account. It seems highly likely that Pierantonio arranged the attack and participated in it. He appears to have talked before with Maringhi about how to deal with the Tassi problem. If he did attempt to kill Tassi it would be naive to think he would not have shared this with Artemisia – and received her approval. After all, he seems to have

had little else to offer her, and, as we shall see, Artemisia seems to respond with rare warmth when Pierantonio defends her physically. But poor Pierantonio fails even in this.

The crate with Artemisia's paintings had reached Rome on 6 March. So it is likely that Artemisia was at work painting the second version of the *Judith*, which she had created after her rape by Tassi, as her husband was plotting his death. If so, the brush was more powerful than an arquebus or a hatchet.

It also appears that an anonymous letter had been written against Artemisia. This seems likely to have been a public pasquinade, along the lines of the libel that Orazio and Caravaggio perpetrated against Baglione. Pierantonio was convinced it was not Tassi – not his style, presumably. Instead he believed it to have been that 'cunning devil Rucellai'; can Maringhi check whether he's in prison or not? The Rucellai were a highly distinguished Florentine family, so Artemisia's growing antipathy to Florence is maybe understandable. On 1 May she declares, 'And when I go there, I would wish to show them how to treat people who have some talent (*qualche vertù*).'

It's a legitimate insight into the shrinking artistic world of Florence – and a reassertion of her ambitions. Artemisia believed she deserved to be respected not because she was good but because she was talented; though she probably would not always have stood by her preceding remark that 'people here conduct themselves in a different way'.

Artemisia painted, in this same angry year of 1620, an even more ruthlessly focused scene of man-killing that narrows the tragic stage of Judith and Holofernes to a box inside which two figures are compressed. *Jael and Sisera*, which survives today in Budapest, can be identified with a reference by Pierantonio in a letter to a painting commissioned by Cardinal Montalto. This was the very Cardinal Montalto whose villa Tassi frescoed.

Jael and Sisera repeats the drama of *Judith and Holofernes*, but is less Shakespearean tragedy than a vicious concoction by his younger rival John Webster. In the Book of Judges, Jael invites Sisera, an enemy of the Israelites, into her tent and lulls him to sleep. In this painting she is driving a tent peg into his skull. As she raises her mallet to pound it in, her face is an impenetrable mask of determination. Perhaps that is not the right word. She looks numbed, like someone automatically repeating an action – as if she's done this before. Her raised arm has an inevitability about it. The arm must raise, the mallet must fall, the man must die. It is compulsive and obsessional.

The intensity of this stripped-down slaying echoes a sculpture that would certainly have caught Artemisia's eye in Florence. Donatello's *Judith* had stood at the gate of the Palazzo Vecchio before it was moved to make way for Michelangelo's *David*. But it was still in Piazza della Signoria, a stark fifteenth-century thunderbolt of godly slaughter in which Judith, dressed like a nun or saint, raises her right arm over her head with the sword poised to sweep down on Holofernes as she holds him by his scraggly hair. Artemisia's Jael has the same raised arm and uncanny drive to kill.

Artemisia was painting some of her most intense and personal pictures in these early years back in Rome. In about 1621 she depicted the ancient Roman tragic heroine Lucretia sitting in the dark, on a bed, her body swathed in white and blood-red draperies that reveal one big leg, a heavy shoulder and her breasts. And that fleshy vulnerability is appropriate. According to the ancient Roman historian Livy in his semi-mythical history of early Rome, the virtuous Lucretia took her own life after she was raped by Sextus Tarquinius. In Artemisia's painting the raped woman is contemplating suicide. She holds a knife in her left hand and holds her breast in the other. Yet she has paused before striking. She looks upward into the night, as if asking for an answer. When the sixteenth-century artist Lorenzo Lotto

portrayed an unknown woman holding up a drawing of Lucretia killing herself, it was an unhesitant statement that she'd rather die than be dishonoured. As Livy tells it, Lucretia's husband and friends tried to reassure her that only Tarquin bore the guilt. But she insisted that she must take her life so no 'unchaste' woman could ever use her story as an excuse. And with that she plunged the knife into her heart.

Artemisia's Lucretia does not look so convinced that she should die for what was done to her. She looks heavenward as if hoping for a more loving view of human suffering. And since this is also an image of Artemisia herself, it is a portrait of her own refusal to hate herself for what Tassi did.

That Artemisia should have been so productive seems remarkable in the light of the disordered nature of the Stiattesis' domestic existence. Soon after their arrival in Rome they moved to new accommodation not far away, on the Via Sora, owned by a Medicean official Luigi Vettori, and for which Maringhi agreed to be the guarantor; this would generate further complexity. And her reunion with her family was both violent and farcical. Artemisia describes to Maringhi a spat with her brother Giulio in which, if her husband had not been there, Giulio would have hit her in the face. Giulio had then grabbed her by the shoulders, and her husband, she reported, 'was going to kill him' (*fu per amazzare lui*). Artemisia concludes by telling her lover that for once, 'I appreciated my husband'.

In fairness, Artemisia in the same letter makes protestations of love to Maringhi – the only thing missing in her life at the moment is him. But she adds a perplexing postscript. The row with Giulio was over a purse that Maringhi had given her and that the Principessa Savelli had taken, presumably with her brother's assistance (the Savelli were Orazio's patrons). Giulio has now returned the purse, but she would like Maringhi to send two more, for the Principessa's sisters.

A war of words was now also being waged between Artemisia and her father. Bernardo Migliorati in his letter and sonnet to Orazio had undoubtedly caricatured Artemisia and Pierantonio as infamous spendthrifts and Orazio, who'd provided a generous dowry and aspired for his daughter to become a Florentine citizen, must have been unable to see her return to Rome as anything other than shameful. Or perhaps he was simply jealous. On 27 March, Pierantonio describes a blazing row in which Orazio refused ever to set foot in their house again. And this is why Pierantonio wishes Maringhi to send their possessions, to prove to Orazio that Artemisia did not live in Florence as an ordinary woman.

Artemisia more than shared Pierantonio's perceptions. Her property, which included her professional materials and tools, was a symbol of her success and an important source of credit for future success. It's sometimes hard to tell where personal possessions end and studio props begin; the Stiattesis request the return of 'that gold net' (*quella trina d'oro*), 'that little porphyry vase'. The problem was that Maringhi's negotiation only concerned what was owed to the Guardaroba. Now other debtors in Florence came out of the woodwork. And Maringhi regarded the Stiattesis' property as the way to satisfy them. Artemisia certainly did not see it that way – she gives Maringhi detailed instructions for muleteers on how her bedding and furniture are to be stowed for transferral to Rome. We see what she does not; that this is a fantasy. The possessions, with the exception of the Ducal paintings and the ultramarine, would stay in Florence, to her disgust.

On 11 April, Artemisia wrote a letter to Maringhi with the news that her son Cristofano had passed away. 'I have almost died with grief in the five days since he died'. There is no reason to think that Artemisia felt anything less when her other children perished, or that her pain went away quickly, even though she seemed able to talk of

other business. Everything is interconnected. Artemisia believes that 'Fortune has turned her back on me' – manifested in the loss of her possessions, the death of her son and the waning of Maringhi's love.

Pierantonio's reaction in a letter written the same day might suggest a resurgence of the apothecary in him. Cristofano, he says, was ill for 11 days. 'We have spread him out' – in other words, had an autopsy performed – to see where the illness came from. Again, there is no reason to doubt the impact of the death of his son on Pierantonio.

It was most likely the death of Cristofano that prompted the Stiattesis to leave Via Sora, a place now associated with grief, and return to Artemisia's old stamping-ground near Piazza del Popolo. This would, however, create another quagmire, with the landlord Vettori suing them for non-payment; Pierantonio may also have sublet the house, or allowed it to be used without permission.

Artemisia now seems swamped by her emotions. On 9 May, Pierantonio says she is in a fevered delirium, 'out of her skin' with anger, and confined to her bedroom. Yet Artemisia's 'rages' are possibly more under control than they seem. On the same day she sends a furious denunciation to Maringhi – 'To my enemy who has fraudulently put on the face of a lover' – but she can stop to quote the poet Ariosto: 'Beware of men in their bloom'.

Artemisia was suffering from jealousy, too. In May she accuses Maringhi of chasing after other women, and complains he is more likely to believe his whore Olimpia than her: 'I am barely able to stop myself screaming when I think of your wickedness'. The following week she warns him that 'you cannot put your foot in many stirrups', and 'to save your caresses for your new woman'. Maringhi must, however, have sent a persuasive letter reassuring her of his love, for on 26 June she thanks him for his 'balm', which has restored her from death to life. She then engages in some decidedly non-courtly banter. She is relieved to learn that Maringhi knows no other woman

than his right hand. She is his as long as she lives, and she will now forgo sex and live chastely. She wishes that he could have sex with her portrait, but that would be a sin, breaking their promises to each other. She loves him for his soul as much as his body.

The truce between them, though, was a brittle one; Artemisia could not accept Maringhi's failure to expedite her wishes concerning her possessions. And this is a point of sympathy between Artemisia and Pierantonio. He understands that she has been forced to swallow a bitter pill, or as he puts it, 'to eat a cabbage with blind men'. On 30 May he mentions to Maringhi that he has filed a suit against his father-in-law, which must almost certainly be connected to the dowry. Perhaps Orazio has withheld part of it, or tied it up in property, which would help to account for Artemisia turning her anger upon her father rather than on her feckless husband. Feckless he certainly was. Pierantonio is outraged that a value of 50 ducats has been put on goods worth 300, and 'like the dowry', he doesn't see why it all has to go up in smoke. Creditors are lying. The procurator appointed to take care of his affairs in Florence is stealing from him, wearing satin sleeves and a new hat on his scudi. A letter written 22 years later, on 7 January 1642, provides an absurd footnote to all this. Pierantonio's younger brother Luca, a clergyman from a tiny place outside Pisa, wrote to the banker Matteo Frescobaldi in Florence seeking his help to recover a significant amount of money which, according to his accounts book, he had lent to Pierantonio and Artemisia. He had sent couriers to them but had no reply.

By 9 July both Pierantonio and Artemisia have recovered some of their customary self-assurance. Pierantonio graciously invites Maringhi to their home; it's before Via Ripetta – entering Rome from the Popolo gate – find the Palazzo Vantaggi, then ask for 'the lady painter' and straightaway someone will direct you. Artemisia is too busy to write herself; she is painting two works for the Duke

of Bavaria. So could Maringhi go to the Galleria and get her some costume jewellery, about 15 gems in total, topazes and so on, of a size matching the enclosed drawing, and a larger pink one for a cloak? She also needs some purses. They will reimburse him. And Pierantonio will send the money to get their diamond out of hock. And it turns out that Artemisia does have time to write a note after all, saying that the Guardaroba's picture will be ready in a month and the Duke of Bavaria may take her back with him on 1,000 scudi a year. On 2 September she takes the time to write, 'I swear to you that I do not have a single hour of relaxation'.

In a letter of 12 September, Artemisia's self-assertion again yields to anger. She describes Maringhi as a traitor. He has 'played the Spaniard', meaning he made promises that he has not kept. We also learn that the Duke's painting has still not been delivered, for she is compelled now to send her husband to convey it, leaving her at the mercy of Rome and her father and brothers. She will give him one month to come to Rome and bring her possessions or their relationship is over. He should treat this letter like the Gospel of Saint John.

Five months later, on 10 February 1621, Maringhi's friend Francesco Cambi drew up a bill of sale for his purchase of Artemisia's possessions, which are meticulously itemized. Maringhi paid her 165 ducats for them.

* * *

In 1621 Orazio Gentileschi left Rome forever. He moved to Genoa, probably taking his youngest son, Marco. This was Orazio's first stop in an ever northwards search for security that would take him to Paris in 1624, and by 1626 out of the Catholic world altogether to paint at the dank, distant, heretical English court.

The following year Pierantonio was accused of slashing the face of a Spaniard, one of a group who had sung beneath Artemisia's window. It is not clear whether he was defending Artemisia from mockery or simply jealous. He is described in the charge as 'a painter'. Pierantonio, whose references to prison in his letters suggest it was a destiny he feared was waiting for him, may have fled with help from Artemisia and others, or he may have lingered on in the family home. In 1623, however, according to the parish census records, he was no longer residing with her.

Around this time the theme of Susanna and the Elders was haunting Artemisia again. In 1622 she signed and dated a new picture of this Biblical tale of voyeurism and lust. It is very different from her prodigious teenaged triumph. All traces of Orazio Gentileschi's style are gone. In fact she is experimenting with a new soft, velvety lushness and subtlety of colour, from cool grey and white banks of cloud misting the blue sky to the silver light that falls on Susanna's hunched body as she shrinks from the Elders' scrutiny. Yet while everything else has changed, the Elders are the same. Once again, Artemisia portrays one of them as younger than the other, with dark hair. And, just as in her earlier painting, they have crept obnoxiously close to the target of their creepy conspiracy. Quorli and Tassi have never gone away.

Susanna is painted both sensually and painfully. There's plenty of her to look at, positively glowing in her shaded garden. But you are drawn to her eyes and they are full of tears.

The garden in which Artemisia sets her Susanna has a new splendour. Above the persecuted woman, at the centre of the pool in which she's dipped her legs, looms a great stone basin. At its base a cupid rides a sea monster that's spouting water from its mouth. This fantastic fountain suggests the artist is looking about her at a new Rome, and trying to adapt her art to its opulence. Even while

Caravaggio painted his low-life scenes at the start of the seventeenth century an unapologetic taste for luxury art was taking hold among Rome's aristocracy and church hierarchs (who were generally the same people).

The Bolognese master Annibale Carracci came to Rome in the 1590s to paint rollicking frescoes of the *Loves of the Gods* on a low curved ceiling in the Farnese Palace, setting the scene for a joyous artistic expansiveness that was reinventing Rome as a place of supreme beauty by the time Artemisia returned. The setting for her 1622 *Susanna* could easily be the Borghese Gardens on the Pincio, surrounded by green space. It was inside Scipione Borghese's adjoining villa that Bernini's statues were competing with Giovanni Lanfranco's eye-fooling ceiling frescoes and Domenichino's painting *The Hunt of Diana*, which Borghese forcibly seized from the rival cardinal who had commissioned it. Artemisia's 1622 *Susanna* could almost be a comment on Domenichino's celebrated 1617 romp. A nymph poses in a pool in the foreground, looking happily out of the painting as she shows the onlooker her breasts and legs. This is pure Baroque pornography. What happened to the Counter-Reformation? By contrast, the suffering of Artemisia's Susanna is a religious experience of martyrdom by the male eye.

Meanwhile, below the Pincio, the artist's quarter had become truly cosmopolitan. Young painters from all over Europe made the pilgrimage to imbibe Rome's inspiration. The Corso area where Artemisia lived was a hive of international ambition. A view painted by Claude Lorraine in 1632 shows a warren of houses nestling below the church of Trinità dei Monti, with the Quirinal in the distance. This was the locality that foreigners like Claude – who worked for Tassi when he first came to Rome – knew best. Claude would be buried in Trinità dei Monti. Other painters and would-be painters who flocked to the city included Gerrit van Honthorst, who was

there from 1610 to 1620 before taking Caravaggism back home to Utrecht; Nicolas Poussin, who arrived from Normandy in 1624 and, like Claude, would die in Rome; and Valentin de Boulogne, who was recorded as living in Artemisia's parish of Santa Maria del Popolo.

Artemisia never had contact with her husband again. Her relationship with Maringhi was more convoluted. Her receipt of money from him might seem a harsh and ignoble end to their affair. Except there's a letter to Maringhi dated the day after from the Bishop of Fossombrone in which he concludes by sending his respects to 'the most gentle' (*gentilissima*) lady Signora Artemisia. They were back together in Florence as a couple. That year Maringhi set out on a two-year assignment in the Ottoman Empire for the Frescobaldi bank. In April 1623, Antonio Selvatico, who was in the employ of Cardinal Maffeo Barberini and staying with Artemisia, wrote to Maringhi who was on his way home and had landed at Ancona on the Adriatic coast, saying she was:

> more beautiful than ever and full of a desire to see your Lordship as far as she is able to say. I have assured her of your speedy return and she has requested that I write to you to say she is waiting. She sends you a thousand hand kisses with more affection than you are able to imagine.

So they were reunited in Rome. What form their relationship took after this we don't know, but it must have involved prolonged separations. In one of her letters to Maringhi, Artemisia talked of acting out the *Metamorphoses* of Ovid, of transforming her body and his soul – that only after such a radical alteration would it be possible for them to be together. But they did meet again.

In the meantime, in 1623 Artemisia's brothers Francesco and Giulio were living with her. It was possibly a salutary experience for,

by 1624, in the year she turned 31, she was living as the head of the household with her daughter Prudentia and two servants. (Francesco and Giulio went to join their father.) This would set the pattern for the rest of her life. She would live independently, run her own workshops and bring up Prudentia, who is known interchangeably in the records of these years by the more exotic name 'Palmira'. Artemisia would also teach her to paint.

Of course this wasn't always easy. She got into a dispute with a servant and, for reasons we don't know, additionally sublet a small apartment on Via Rassella. Artemisia was well known in the artists' quarter, standing godmother to a girl also named Prudentia, and another named Artemisia at San Lorenzo in Lucina. She had become a source of fascination to her fellow artists, and on an international scale. In 1625 Pierre Dumonstier II, who had just arrived from Paris, made a careful and reverent drawing of her right hand. Posed in a calm and commanding way, with a delicate brush between her first two fingers and her thumb, Artemisia's hand is adept and emphatically feminine. Above his work Dumonstier wrote that it was drawn, 'This last of December 1625 after the dignified hand of the excellent and knowledgeable Artemisia, gentle lady of Rome.' On the back he adds that while the hands of Aurora are famous for their beauty, 'this one is more worthy by a thousand times, because it has the knowledge to make marvels that ravish the most judicious eyes.'

Artemisia had painted an Aurora in Florence for the poet and mathematician Niccolò Arrighetti, which can possibly be identified with a painting in a private collection in Rome in which the goddess stretches out her hands.

Although Dumonstier's drawing depicts only Artemisia's hand, it was intended as a portrait of her talent. Artistic savoir-faire was located, according to Dumonstier, in the painter's actual hand. That

makes it, for this scion of a French artistic dynasty who was never to become renowned in his own right, one of the sights of Rome, up there with the Colosseum and St Peter's.

Simon Vouet felt the same way. From 1624 this Paris-born artist was painting scenes from the life of Saint Francis in a chapel in San Lorenzo in Lucina. He'd been in Rome for a decade and was elected president of the Academy of St Luke. A painting credited to him and dated to the mid-1620s has been identified as a portrait of Artemisia. It depicts a female painter in a golden dress with a palette and spare brushes in her left hand. Her right, meanwhile, holds a thin brush with a refinement that resembles the *Right Hand of Artemisia* as drawn by Dumonstier. She wears a medal depicting the Mausoleum of Halicarnassus, which was built by Mausolus's widow – Queen Artemisia.

In both these homages you can feel the raw energy of her art being muted under polite French compliments. Both are erudite, scholarly works. The drawing of her right hand would have fitted well into the 'paper museum' of curious drawings that was being assembled at this time by the papal bureaucrat, scientific enthusiast, antiquarian and art collector Cassiano dal Pozzo. Vouet's portrait actually did enter Cassiano's collection of the unique and interesting.

The fact was that Rome's art was going upmarket. The Caravaggisti were on their way out. The classical heritage of Annibale Carracci was in the ascendant. The accession of Cardinal Maffeo Barberini as Pope Urban VIII in 1623 saw a reordering of art and thought. Urban had previously encouraged Galileo but as Pope he threw him to the Inquisition. And although as a younger man he'd actually posed for Caravaggio, as Pope he presided over the triumph of a much loftier Baroque that started in 1624 when Bernini created the towering black and bronze altar canopy in St. Peter's, the Baldacchino, its spiralling columns like bass notes sounding God's ineffable power.

Artemisia was famous, yet her approach to art was falling out of fashion. In 1625, when she painted a new version of *Judith and Her Maidservant*, she was still deep in Caravaggesque shadows. This time the action takes place in Holofernes' tent, whose red velvet hangings and fine green-topped table give a sense of opulent exoticism. As Abra shoves the severed head into a bag, Judith has heard something. She motions silence. They both stare at the tent door, bodies stilled, action suspended, eyes alert. It's as if, as she rethinks the story in her early thirties, Artemisia is less struck by violent action than by hesitance. This is similar to the way she depicts Lucretia stilled in contemplation before her act, or the paralyzed tearfulness of the 1622 *Susanna*.

The young woman who painted ruthless acts of heroic aggression has become a more meditative artist. This version of *Judith and Her Maidservant* is a midnight moment of anxious introspection. She achieves it by changing the light. Instead of a bold, mysterious bolt of illumination, she reveals this moment with a solitary candle on the table top. Because it's at the rear of the tent, our view of Judith's face is cut by a circle of shadow. This use of candlelight to create an inward mood is reminiscent of such northern European Caravaggisti as the Utrecht school and Georges de La Tour. In her hands it is the guttering flame of action suspended. The hero has become a thinker.

There's no doubt that by the mid-1620s Caravaggio's realism was much more appreciated outside Italy than it was in Rome. Between 1625 and 1626 Artemisia painted a Mary Magdalene acquired by Fernando Afán de Ribera, 3rd Duke of Alcalá, who was in Rome as the Spanish ambassador to Urban VIII. It would end up in Seville Cathedral, where it still hangs today.

It's another painting of meditative stillness. Orazio Gentileschi had always seen the gentle side of Caravaggio. Here Artemisia also responds to those moments of ecstasy and slumber. Her *Sleeping*

Magdalene sits in a fine chair wearing fine jewellery but she has slipped into a reverie in which earthly things no longer matter to her. It is a sleep like death.

Diego Velázquez was already painting Caravaggesque scenes on the streets of Seville before 1620. In his painting of *Christ in the House of Martha and Mary*, completed in 1618, he shows a sympathy for the lot of working women as a young kitchen girl miserably pounds garlic. There was an appetite for the tough, bleak eyes of the Caravaggisti in Spain, the most proudly Catholic of nations, where the harshness of life was taken as given. And this sensibility was to offer Artemisia a new future as the parameters of her own career became harsher.

For Artemisia was becoming caught in a paradox. She had fame and admirers. A medallion had been issued with her portrait in profile with a Latin inscription: 'Artemisia Gentileschi Famous Painter' (*Artemisia Gentileschi Pictrix Celebris*). Yet important commissions and patronage were proving more elusive. Not many works by Artemisia have survived in Rome, which says something about the big collectors' comparative coolness towards her work. Artemisia was in danger of becoming a mascot, a celebrity, whose art was less important than the idea of it. She must have been pulled as well as pushed out of Rome, but we don't know what the forces were. As early as 1626, and certainly by 1627, Artemisia was in Venice, stopping off at the university town of Padua on the way.

5

Mary

rtemisia lived for about three years in Venice, the Serene Republic, where Baroque art had yet to rival the sixteenth-century masterpieces of Titian, Veronese and Tintoretto. It might have been fertile ground, like Florence, for Caravaggio's most cutting follower. She lived in the *sestiere* of San Marco, in the parish of the church of San Fantin, which contained a miraculous icon of Mary from the East. Artemisia's fame was celebrated. Anonymous poetry, possibly by the young patrician Gianfranco Loredan, took inspiration from her *Lucretia*, her *Susanna* and, now lost, her 'Cupid, in contest' ('Amoretto in Parangone') – which sounds like another homage to Caravaggio's *Sleeping Cupid*. In a letter he also praised the achievements of her tongue and her brush. His teacher Antonio Colluraffi composed madrigals to her, which included the verdict that while other artists deceived birds, the lady painter (*la pittura*) Artemisia 'Gentil' deceived art itself and conquered nature – an allusion to the famous competition between the ancient Greek artists Zeuxis and Parrhasius. And so on.

It's likely that Artemisia found Venice enigmatic and exhilarating, a place apart with peculiar customs and rituals; of more interest to male visitors, it had a reputation for libertine freedom. The English traveller Thomas Coryat in his 1611 book *Coryat's Crudities* raves about the courtesans of Venice, whom he watched seducing their admirers at the theatre and – to better inform his readers – visited at home.

Yet the liberty of Venice was not just sexual. This ancient maritime republic had kept its distance from the Counter-Reformation. Its people were pious, but in their own way. The Inquisition was carefully restricted in its investigations. Venice was a centre of publishing and science, where Galileo had been free to think without the threats he suffered in Urban VIII's Rome. And while painting might have languished since 1600, the shimmering beauty of Venice's canals and mosaics was mirrored in the passionate, even erotic sounds invented by Claudio Monteverdi, pioneer of opera and choirmaster of San Marco.

Artemisia was admitted into one of Venice's literary and cultural clubs, the Accademia ne' Desiosi. We know this from the inscription on a print from about 1627, engraved after a lost self-portrait. She poses with unkempt hair, looking like she's far too serious an artist to take time over such trivia. She displays a bold energy as she looks askance out of the picture, which is framed with an inscribed strip describing her as 'a most famous Roman painter'.

Yet the free atmosphere of Venice was fully experienced only by the aristocratic men who ruled it. The visibility of courtesans was a stark contrast with the sequestered lives of upper-class wives and daughters who were expected to wear veils and travel concealed in gondolas. Convents were prisons for women who weren't married off, raged the Venetian feminist, Artemisia's contemporary, Arcangela Tarabotti.

The stardom Artemisia enjoyed in Venice, with intellectual men courting and adoring her, was a consequence of her novelty as an accomplished professional female painter in a society less liberal than it seemed. Many years later, in 1653, Loredan, who enjoyed a sparkling literary and political career, published a collection of poetic 'Humorous Epitaphs' (*Epitafi Giocosi*), written in the first person; it included one for Artemisia, who was mistakenly believed dead.

Its message was loud and clear: I, the deceased painter, had been promiscuous. I had put down my paintbrush and taken up the chisel to carve cuckold's horns upon my husband's head; and – punning on her surname – ever 'gentle' to all comers, I am now 'gently' eaten by worms. So much for Venetian courtesy.

Unfortunately only one extant painting at most has been identified from Artemisia's Venetian period, and even that's a broad guess. The picture in question depicts Esther swooning as she begs the puffy-sleeved Ahasuerus to have mercy on her persecuted people. Perhaps it was painted in Venice in homage to the narrative realism of Veronese. Perhaps it wasn't. In truth, wherever she created this scene, it doesn't have much electricity.

There is evidence that Artemisia drew in Venice. The madrigal-composer Colluraffi requested from her a drawing of a mother bear licking her newborn cubs for another club, the Academy of the Unformed. It's an image taken from the ancient natural history writer Pliny the Elder, who claimed that bear cubs are born as flesh without form; their mother licks them into shape. Colluraffi's request seems to have been a clumsy tribute to Artemisia as representative of female creative power.

While Artemisia was being complimented by the Venetians, her father and brothers were trying to prosper in London. Orazio's initial employer in England was the influential courtier the Duke of Buckingham, former favourite of King James I and key adviser to his son Charles I, until he was assassinated in 1628. King Charles was one of the most avid art collectors in Europe, prepared to spend astronomical sums of money on entire art collections from Italy. He was in the process of purchasing the famous collection of the Dukes of Mantua, the Gonzagas. When another collection came on the market in Genoa in 1627, Orazio managed to get Giulio and Francesco sent there from London with a view to buying it for the king. They were

supposed to meet the musician and royal art expert Nicholas Lanier in Milan but he was in Venice, negotiating the Gonzaga purchase. So Francesco spent the King's cash on a trip across northern Italy while Giulio stayed with relatives in Pisa. Embarrassed, Orazio sent a letter to the King in which he blamed Lanier.

Art acquisition would cause Orazio further headaches when he questioned the purchases of his rival Balthazar Gerbier, whose reaction was to have Francesco and Marco arrested for debt. Giulio later ran into Gerbier on the Strand in London and hit him on the head with his scabbard; Gerbier then ambushed Marco. It was the Gentileschi boys, Francesco and Marco, who were imprisoned.

It's possible that while Francesco and Giulio were mucking up their mission for the King, Artemisia met Lanier in Venice. We know that they encountered each other at some point because the physician Théodore de Mayerne recorded Lanier's description of Orazio's technique for mixing a drop of amber varnish with pigments on the palette, which he had heard from Artemisia. An English gossip said Lanier was in love with Artemisia.

However, the most important lesson Venice appears to have taught Artemisia was the value of the Spanish as art collectors. In 1628 Artemisia was paid for a commission by Philip IV of *Hercules and Omphale* – a theme usually treated as a comic inversion of sexual roles in which the hero is forced to spin for the Lydian queen. She also became reacquainted with the Duke of Alcalá. The Spanish collector, who had bought her *Sleeping Magdalene* in Rome, acquired more paintings from her when she was in Venice. In 1629 he was appointed Viceroy of the Spanish kingdom of Naples. And this was to shape her next move.

In 1630 bubonic plague broke out in Venice. It was a regular, lethal visitor to Artemisia's world, especially in cities where dense housing and poor understanding of infection could lead to sudden

surges in mortality. This time it would kill half the population, a catastrophe commemorated by the great sad church the Salute, the city's most impressive piece of Baroque architecture. Artemisia fled to Naples. She was jumping out of the frying pan into the fire.

Just how fiery artistic life in Naples could be was revealed by the fate of another outsider who dared to take work from local painters. Just a year after Artemisia arrived, in 1631, the renowned artist Domenichino travelled from Rome to Naples to paint the Chapel of the Treasury in the cathedral, dedicated to the city's patron, San Gennaro. As soon as this artist from the north arrived in the sprawling, ancient port on the Bay of Naples, overlooked by Mount Vesuvius, he received death threats. The Viceroy promised to protect him, but after sticking it out for three years he rode off in fear for his life, 'accompanied only by my disgust and my suspicions', as he wrote to his patron Cardinal Aldobrandini. Domenichino was being menaced by a 'cabal' of artists led by Jusepe de Ribera, who had come from Spain to make a career in Naples and had no intention of letting a fashionable Bolognese artist take the bread out of his mouth. Domenichino took a year to overcome his terror and return. Then he became convinced his food was being poisoned; in fact it's possible he was murdered in 1641.

There's no record of any murder attempt on Artemisia in Naples, but its violent atmosphere made her anxious. Already in August 1630, she writes a letter trying to arrange a weapons licence for a cleric working in her household. Six years later she would be desperate to get out of the place, 'because of the warlike tumults, the badness of life, and the expense of things' (*se per li tumulti di guerre, come anco il male vivere, et delle cose care*).

Could these 'tumults' mean the murderous feuds among artists? Perhaps, but there was plenty of stress on the streets as well as in the studios. Naples had a very large, poor, alienated population of around

300,000 people – the biggest by far of any city in Italy – ruled with an iron fist by the Spanish Empire. Public torture and executions by the Viceroy's government and the Holy Inquisition were meant to terrorize the miserable populace into submission, but it was a powder keg of a place, and art had a vocation to succour the poor and wretched.

At least that's what Caravaggio concluded. When the runaway murderer fled to Naples in 1606 he painted a popular masterpiece that calls for compassion on the mean streets. *The Seven Works of Mercy* still hangs, as it has done for more than four centuries, in the church of a charitable brotherhood, the Pio Monte della Misericordia, founded by a confraternity of pious young nobles who dedicated themselves to philanthropic acts. Caravaggio's painting is set on the dark, narrow streets of central Naples by night. The acts of mercy include a woman feeding an old man breast milk through the barred window of a prison – taken from a famous story of Roman charity – and a deacon holding up a lighted torch as a bare-footed corpse is carried through the street to be buried. There's a desperation to these deeds of mercy, a sense of the squalor that makes them urgent. Even burial is not something the poor of Naples can take for granted.

Artemisia had a studio near Via Toledo, in the heart of the merciless city, close to the harbour. Just like her hero Caravaggio, she connected with popular religion in Naples. Her earliest surviving work in the city is an Annunciation that shows instant mastery of the vivid folk costumes, ethereal angels and shadowed intensity of the Neapolitan Baroque. Two cherub heads float in darkness flanking the Dove of the Holy Spirit as it flies out of a golden heaven through parted clouds. A feminine Angel Gabriel kneels in gold, orange and black robes, with dark hair and soft swan-like white wings, addressing a Virgin Mary who bows modestly and lowers her timid eyes. It's not subtle or sophisticated but it has a vibrancy that belongs

perfectly on the streets of Naples. This is art as communal hope.

Why was Artemisia so instantly attuned to the southern Baroque atmosphere of feverish piety? As we have already seen, she started painting for the Duke of Alcalá before he became Viceroy of the Kingdom of Naples, though many works that she sent to Spain through his patronage have disappeared. Spain's viceroys had ruled in Naples since 1504, making it part of a proudly Catholic world empire that stretched from Vienna to Veracruz, from Flanders to Peru. Spanish taste ran to the rawly religious and shockingly real. This made Naples the natural city for a Caravaggista. In this tense urban environment, where Caravaggio himself had shown how to paint for the people, to work out redemption on the streets, artists were still loyal to his tough yet loving art, even though it was now considered utterly unfashionable in Urban VIII's Rome. The Spanish painter Ribera, who dominated the Naples art scene, was a brilliant interpreter of Caravaggio; his brutal realism leaps at you like a knife out of velvet shadows.

Artemisia, however, was the friend and maybe teacher of an artist who was to become Ribera's rival – a dangerous thing to be, if the stories of Ribera's gangsterism are true. This was Massimo Stanzione, who like Artemisia was living in Naples by 1630. Her *Annunciation* has a lot in common with his intensely coloured, ardent icons of the faith. And you can see her influence on him in sympathetic portrayals of women, such as his *Woman with a Cockerel*, with her bead-encrusted red and gold costume. Their creative relationship, and the example of Caravaggio that she always had before her, helps explain why Artemisia adapted so quickly to southern fervour.

In December 1631, life in Naples became more heated than usual. Vesuvius erupted after months of earthquakes. Streams of lava and clouds of toxic gas sent 40,000 country people fleeing into Naples before a tremendous explosion blew the top off the conical mountain

and reduced it to today's barnacle shape. Around 4,000 people died. It was time to call on San Gennaro. The city's saint protected it from the volcano in a ritual that still exists today – a vial of his dried blood was held aloft and the crowd saw it liquidize; this miraculous red fluid defended Naples from red streams of lava.

The art of Baroque Naples is steeped in insecurity and dread. If it looks macabre, that's because death was always imminent, if not from violence or disease, then from rivers of fire. This was why the Chapel of the Treasure of San Gennaro, where his protecting blood was kept, was the most ambitious project in the city and Ribera fought against interlopers until he finally got to paint there himself. There were other prestigious commissions, too, as Spanish gold and popular piety fused in an extravagant yet bleak version of the Baroque. In 1638 the new church of Purgatorio ad Arco, in Via dei Tribunali, would unveil its weirder imaginings. Upstairs, it is an opulent space full of polished wood and glistening marble. Downstairs, a huge sepulchral void leads to a labyrinth where, since the seventeenth century, the skulls and bones of the dead have been laid out, and are still part of city life. The altarpiece upstairs is a swirling vision of the *Virgin Mary Redeeming Souls from Purgatory*, painted by Artemisia's friend Stanzione.

Artemisia also painted an altarpiece promising salvation and supernatural aid for the Bay of Naples in 1636 and 1637. *San Gennaro in the Amphitheatre* shows the early Christian bishop and martyr Gennaro, or Januarius, in full clerical regalia, with gold mitre and stole, soothing and subduing the lion that was supposed to eat him in the arena. The commission came from the Spanish bishop for the cathedral of Pozzuoli, a city north of Naples, regularly shaken by earthquakes from the underground volcano of the Phlegrean Fields. It was part of a new decorative scheme to give thanks for protection from the eruption of 1631, and Artemisia

contributed two more paintings, an *Adoration of the Magi*, and a *Saints Proculus and Nicea*, a Christian son and mother who were martyred in the Pozzuoli amphitheatre – the site of San Gennaro's victory and an atmospheric ruin, in Artemisia's time and today.

Artemisia's miracle is painted with a grittiness and sombre roughness that makes it seem hard-won instead of merely triumphal. When Ribera, by hook or by crook, finally got to paint his own San Gennaro story in the Tesoro, he would abandon his usual realism to portray a ridiculously relaxed, handsome young saint. Artemisia's San Gennaro is by contrast a man who has suffered. He seems to lean heavily on his crozier. There are miracles but they come from pain and prayer.

As the Duke of Alcalá had probably facilitated her transferal to Naples it was natural that Artemisia would look for employment from the Spanish court. She claims in 1630 to be working on paintings for 'the Empress'; this was María of Austria, sister of the king of Spain. Artemisia makes this straightforward boast in a letter to Cassiano dal Pozzo in Rome. The tasteful and learned collector Cassiano, secretary to Cardinal Francesco Barberini, was Artemisia's lifeline to the Papal City. It was Cassiano who arranged the weapons licence. Artemisia also asks him to send her six pairs of the most beautiful gloves, 'which I have to give to the ladies' – that is, the ladies of the court. By December she had finished a self-portrait for Cassiano, and to keep out the cold would like a gift of some gloves of her own, and some slippers.

Artemisia, as in other cities, also moved in intellectual circles in Naples and again was an inspiration to poets. They show us not Artemisia the religious artist but the portraitist and interpreter of classical mythology. The poet Girolamo Fontanella, who died young, seems to have commissioned or even simply been given paintings by her. These included *Apollo with a Lyre*, where the god appeared more glorious 'within your canvas than in heaven', and his portrait:

'Cruel woman, is it not enough to have taken prisoner my soul and my bound heart that, thief of love, you also steal my face?'

The romantic expression is completely conventional but the friendship was doubtless sincere. Another poet, Francesco Antonio Cappone, dedicated two poems to Artemisia in a collection published in 1643: 'From where oh noble Painter come the colours that you paint with so skilfully, which in your oils make peace in one theme, both of the Night and of the Sun, shadows and glories?'

Beneath the generic flattery there might lurk an allusion to Artemisia's Caravaggesque use of light and shadow.

The Duke of Alcalá was replaced as Viceroy of Naples by Manuel de Acevedo y Zúñiga, Count of Monterrey. It seems to have done Artemisia no harm because she was asked to paint *The Birth of John the Baptist* for the Hermitage of St John in the park of Madrid's Buen Retiro palace. It was a prestigious royal commission but, to get that in proportion, Massimo Stanzione was asked to provide four paintings to go with hers. Artemisia's painting is a warmly lifelike scene of female sociability that comes straight out of the streets of Naples. The women attending John the Baptist's birth wear bright shawls and headdresses, as they might do to chat on a Neapolitan piazza. Stanzione's pictures for the Buen Retiro are more florid and grand. You can feel reality and emotional truth drain out of them with every brushstroke. As in her painting of San Gennaro, Artemisia puts humble humanity into a sacred picture. She doesn't lard it with supernatural signs. She has set the birth of John the Baptist among real people, who mark this birth as they would any other. Gossip mingles with concern, work with waiting around, as inconclusively as we experience in real life. We're seeing the backstage of history here, the mess of inconsequence in which 'great' events take place.

It is, as ever, Artemisia's understanding of Caravaggio that grounds her. In about 1633 to 1634, she painted *Corisca and the*

Satyr, in which a lustful half-man, half-goat creature chases a young woman who eludes him because she's wearing a wig that comes off in his hand. Artemisia took this scene from *The Faithful Shepherd* (*Il Pastor Fido*), a hit comic play set in the world of pastoral. The joke is on the mythological art of her contemporaries, reducing erotic chases such as Bernini's *Apollo and Daphne* to a blunt humiliation of the predator.

Corisca and the Satyr proves that the contemporary Neapolitan artist with whom Artemisia had most in common was Ribera after all. Both of them were true followers of Caravaggio. Ribera, too, knocks the enchanted classics down to earth. He paints the satyr Silenus as a fat boozer, the flaying of Marsyas by Apollo as an act of sadistic brutality, the punishment of Tityus in Hades as an Inquisition atrocity. This was a Spanish gravity. In mainland Spain, Velázquez debunks pagan myth with such a novelistic imagination that it becomes sublime poetry. Bacchus drinks with vagrants, Mars is a depressed soldier and Venus a model gazing sadly into a mirror. If Artemisia painted a lost *Apollo with his Lyre* in Naples, was it an act of rivalry with Ribera's *Apollo and Marsyas*?

One reason Velázquez, Ribera and Artemisia were tempted to reduce myth to humble reality was that the pagan gods were filling palace walls as rapidly as saccharine saints were clogging up churches in these years, as the Baroque became an excuse for acres of spectacle. Pietro da Cortona's stupefying *Glorification of Urban VIII's Reign*, frescoed on the biggest ceiling in the Barberini Palace in Rome between 1633 and 1639, is one of the most awe-inspiring, yet least moving works in Italy. This kind of bombast contained the seeds of Italian art's decline.

From the profundity of Caravaggio to the hyperbole of Pietro da Cortona was a backward step. And while Italian art lost its soul behind some of the most superb facades – and staircases and fountains and colonnades – ever built, the impact of Caravaggio

throughout Europe inspired insight and compassion in the art of Spain and the Netherlands. The greatest artists of the century would include Velázquez, Ribera and Zurbarán, as well as Hals, Rembrandt and Vermeer.

Artemisia shares their concentration on human experience. She'd got it from the source, from Caravaggio himself, as well as her own life. At least in Naples there was still a place for a Caravaggista, but she knew she deserved better.

Artemisia did not merely want to make a living. She didn't want to be some unremembered artist whose paintings gathered dust in the side chapels of southern churches. She wanted to be famous throughout Europe. She was forthright about this. Ambition mattered to her and she never concealed it. In 1635 she wrote to Duke Francesco I d'Este, Duke of Modena, saying she wanted to give him paintings as 'a way of honouring my fame'. She vaunts in the same letter of her reputation among the crowned heads of Europe, and this pride had some foundation. From her base in the violent, expensive, volcanic Mediterranean port she campaigned energetically to get the patronage of princes and dukes. But which court would take the bait?

One proof both of Artemisia's fame and her desire to be famous is a long-lost painting that was listed in an inventory of King Charles I's art collection in England at the end of the 1630s. The collection's conscientious custodian Abraham van Doort – who was to kill himself because he thought he had lost a royal miniature – describes it in his distinctive Dutchized English as follows:

Done by Artemisio Gentellesco baht bij jus M
Item a woemans picture, in some bluish draperie with a trumpet in her left hand Signifying ffame with her other hand having a penn to write being uppon a Straining frame painted uppon Cloath.

Van Doort notes that this *Allegory of Fame* was 'baht bij juw M', that is, 'bought by your Majesty'. So it seems the King had a specific enthusiasm for Artemisia's work. A painting by her of *Tarquin and Lucretia* had also entered his collection by 1633 or 1634.

Orazio Gentileschi, meanwhile, was esconced at the English court with a reputation for truculence. Charles had effectively fobbed him off as an artistic pet onto his Queen, Henrietta Maria. Their marriage had started badly but they shared a love of art, and Henrietta Maria lavishly decorated her palace, the Queen's House in Greenwich, with works by contemporary Italian artists. Guercino was invited to London, but this fervent Catholic refused to go among the English heretics. In fact Henrietta Maria was a proselytizing Catholic who encouraged her husband's most Papist tendencies, and the Papal court in Rome saw the value of sending Baroque art and artists to coax the stray English Protestant sheep back to the fold. Bernini himself carved a portrait of Charles.

Charles must have liked what he saw of Artemisia's work, for in 1635 her brother Francesco was sent to Naples to extend to her the King's invitation to the English court. Artemisia's response was swift – she set out to use the invitation to impress Italy's courts and try and win a place at one of those instead. Italy was, after all, the artistic centre of Europe. Why would she leave for some northern backwater?

First she sent Francesco to Rome to give one of her paintings as a gift to the Pope's nephew, Cardinal Antonio Barberini. Presumably Francesco would also let it drop that he'd been sent back to Italy to see his sister on behalf of the English king. But Artemisia had no direct contact with the Barberini family. Her only protector (*protettore*) in Rome was Cassiano dal Pozzo. Five years earlier Artemisia had negotiated with Cassiano over a self-portrait he commissioned from her. Now she asked for his help in getting Francesco an audience with Cardinal Antonio.

A few days later Artemisia sent her brother to see Francesco I d'Este, Duke of Modena, who also happened to be in Rome. Her letter to the Duke brags that her brother has been 'sent by His Majesty the King of England to take me into his service'. She's clearly touting her brother and his mission to the Italian patrons she'd much rather have. But this flurry of self-promotion was to end in frustration. The Duke of Modena wrote back cordially, praising her work, but there was no hint of any further patronage from him.

When she sent a similar gift of her work to Ferdinando II, Grand Duke of Tuscany and the son of her old employer Cosimo II, in that same year, the result was much more depressing. Ferdinando did not even acknowledge the unsolicited art. Artemisia wrote humiliatingly to Andrea Cioli, the Grand Duke's Secretary of State, in September 1635, asking if the paintings had gone down well. On 9 October she wrote to Galileo, who was under house arrest at his villa in Arcetri, in the hills on the outskirts of Florence, begging him to intervene with the Tuscan court. It might seem insensitive of Artemisia to have asked for his help when he'd so recently been released by the Inquisition, but Galileo may actually have intervened, for she soon got a more positive response from Cioli. There was no commitment to giving her a position or even major commissions, however.

There's a nice postscript to Artemisia's letter to Galileo. She asks him to reply to her care of Francesco Maria Maringhi. Her old lover was still on the scene.

Artemisia also had to think about her daughter Prudentia. In 1634 an English courtier called Bullen Reymes dropped in on Artemisia in Naples, in between visiting brothels. He saw her daughter Prudentia paint and play the virginal. In December 1635 Artemisia sent an artistic exercise by Prudentia to Andrea Cioli in Florence, asking him not to laugh at it as she was just a girl. This doesn't suggest much confidence in her daughter's talent. By 1636

Artemisia was planning Prudentia's marriage. Intending to travel to Pisa to sell some property to pay for it, she again solicited Medici patronage for a four-month stay at the Florentine court.

The following year she came clean to Cassiano dal Pozzo about her insecure finances. Without capital of her own or a court salary she was completely dependent on how much she could get for individual canvases. That's why she needs his help to sell paintings to Cardinals Francesco and Antonio Barberini, she explains. That will enable her to fund Prudentia's dowry, get her off her hands and free Artemisia to come and see her friends in Rome. In a postscript, she makes a surprising request to the Cardinal's secretary: 'Please send me news of the life or death of my husband.'

It's not difficult to imagine why Artemisia might have needed to know whether Pierantonio Stiattesi was still alive, if their daughter was getting married, and especially if Artemisia needed to dispose of property. Why the distinguished Cassiano dal Pozzo would know anything about this matter is more mysterious.

The next of her letters that is known once again attempts to woo the Duke of Modena, telling him that patrons of his quality serve as a goad to 'ambitious spirits' such as herself to 'advance their glory'. This letter was sent from London on 16 December 1639. Artemisia had been so short of options in Italy that she had finally accepted the standing invitation from the King of England and Scotland.

6

Artemisia

She sailed into a country on the edge. In Roman diplomatic circles it was known that big trouble was brewing between Charles I and his Parliament. Cardinal Francesco Barberini worried that the theme of the huge painting he arranged for Guido Reni to send from Italy to decorate the Queen's bedchamber in Greenwich, the meeting of Bacchus and Ariadne, might be too provocative, 'especially in these parliamentary times.' He was right to worry. Charles had by now spent many years alienating his subjects. Introspective and touchy, he supported a movement to restore fine vestments and decor in English churches that was seen by purist Protestants as insidiously Catholic. His attempt to rule without Parliament while taking extraordinary measures to raise money racked up the tension further. And all the while he was lavishing cash on art from Catholic Europe that looked like rank idolatry to people with 'Puritan' Calvinist beliefs. Charles I's art collection was not incidental to his problems. It embodied them.

The collection contained some of the most revered of all Catholic religious works of art to shock Puritans or even mainstream English Protestants, including Leonardo da Vinci's *Saint John the Baptist* (for which Charles had swapped a Holbein and a dodgy Titian), Raphael's cartoons for tapestries in the Sistine Chapel, and Titian's *Supper at Emmaus*. Yet the overall atmosphere of this stupendous array of European art was more sensual than sacred. In Titian's *Venus and Mars* an organist can't help staring at the nude goddess

as he plays for her. Correggio's soft, erotic brushwork makes his painting of a satyr spying on the sleeping Venus similarly outrageous. Both these hedonistic Renaissance paintings were in Charles I's collection.

Orazio Gentileschi, whose art had pride of place at the Queen's House in Greenwich, appealed to the same court taste for Italian sensuality in his painting *Joseph and Potiphar's Wife*, which he painted in London between about 1630 and 1632. A sexually voracious, powerful woman tries to tempt the uninterested Joseph into her bed. Yet Orazio's extreme precision in this chilly canvas is the opposite of the soft, sensual suggestions of Titian or Correggio.

Artemisia on her arrival would have found London to have had a lot in common with Naples. It was big, and getting bigger. It was also a port where merchandise and money circulated through the filthy narrow streets. Perhaps it was all too familiar, except for the cold and grey skies. But southeast of the city, the royal residence of Greenwich spread out in parkland on a hill above the Thames. It must have seemed almost civilized.

The Queen's House is a lonely survivor of the Stuart court in today's London. Its cubic great hall is one of the most imaginative architectural spaces in Britain, a geometrical confoundment conceived as the setting for masques and intrigues. This small but perfect palace, begun in 1616, is said to have been a gift from James I to his Queen, Anne of Denmark, to apologize for cursing in front of her. Yet it was not finished until the reign of his son Charles I, when it became, in turn, Charles's gift to Henrietta Maria. Inigo Jones, who designed it, had been to Italy and studied the radiant classicism of the Veneto architect Andrea Palladio. The Queen's House was the most purely classical and Italianate structure that had been built in Britain since the Romans left. Perhaps it made Artemisia and her father feel at home in this foreign land.

Their art was displayed here side by side. Van Doort lists paintings in the Queen's Withdrawing Chamber at Greenwich in numerical order. He puts works by the Gentileschis first and second, suggesting their pictures had pride of place and hung side by side. Number One was Orazio's *Lot and his Daughters*. Second came Artemisia's *Tarquin and Lucretia*. Lower down the list are Van Dyck, Giulio Romano and Tintoretto. In her other Withdrawing Chamber in Whitehall Palace, meanwhile, Henrietta Maria had a *Susanna and the Elders* 'done by Artimisio Gentillesco'.

Orazio was by now an old man well into his seventies, working on what he must have known would be his final work, a cycle of allegorical ceiling paintings for the Great Hall in the Queen's House. This was not a fresco but a set of canvases mounted on board and suspended in a gilded wooden grid. That was not all. Such was the Queen's enthusiasm for Orazio that the entire cubic room created by Jones was given over to his art. The walls below the ceiling were hung with his history paintings, including a depiction of *The Finding of Moses*, in which a company of confident, courtly women pose by the Thames.

The Queen's House was Orazio's domain but his daughter too was welcome there – at least in Henrietta Maria's eyes. The meeting of father and daughter after so many years may have been awkward. In fact we cannot be certain that they met at all. Orazio died on 7 February 1639, ten months before Artemisia wrote her only letter from London. He was buried beneath the high altar of the Catholic Queen's Chapel at Somerset House in the heart of London, which would be destroyed in the Civil War. However, Artemisia's last letter from Naples before turning up in London is dated 24 November 1637, so it's perfectly possible she was in London in 1638. Francesco had permission to go to Italy that year and could have accompanied her. And the sheer number of her paintings in Van Doort's 1639

inventory suggests she had established herself at the English court before he compiled it. So the chances are she was there for the last months of her father's life.

In a brilliantly characterful portrait drawing by Anthony van Dyck, the elderly Orazio looks suspicious and unhappy, like King Lear – old before he is wise. Maybe that's too much to see in a sketch. In January 1639 he dictated his 'testamentary intentions', a less legally enforceable version of a will, which was taken down in English. Orazio Gentileschi of the parish of St Martin-in-the-Fields wished his estate to be divided between his three sons. Giulio was to get more than Francesco, because he had children and was less able to earn a living. Marco was to have 'leaste of all because he hath beene an undutifull child and hath putt me to greate charges'. Thorough provisions were made for Orazio's servant Francis Tarilli, who also witnessed the deposition. Artemisia was not mentioned. Her disinheritance was in accordance with the Italian practice of 'exclusion on account of the dowry'. Given Orazio's castigation of Marco she may have been relieved to have been passed over in silence.

After the debacle that ended her Florentine career, father and child had argued violently. That had been a long time ago. If Artemisia did have anything to do with the ceiling of the Queen's Great Hall, it may have been a fraught collaboration. In her letter to the Duke of Modena at the end of the year she says nothing of her father's death.

Whatever emotions were released by Artemisia's last encounter with her father it stimulated an act of rivalry that produced her greatest painting. Far from loyally holding brushes while he finished his canvases, she showed how it could be done better. In the allegory-laden court of Charles I, where Orazio's ceiling was just the latest expression of a narcissistic art of royal self-deception, she turned such empty symbols into the stuff of life.

Charles and his Queen, who chose to see themselves through a gauze of Baroque mythological pomp, loved allegories. Gerrit van Honthorst, who had started out as a Dutch disciple of Caravaggio's raw reality, painted a colossal canvas for the King in 1628 in which the royal couple appear as Apollo and Diana enthroned on a cloud, while the Duke of Buckingham plays Mercury, leading the seven Liberal Arts out of the darkness into the luminous new Caroline Age. The Liberal Arts – Grammar, Logic, Rhetoric, Astronomy, Geometry, Arithmetic and Music – are all personified as women, according to convention.

Charles I's appetite for such imagery was as misguided as his entire cultural, religious and political enterprise. Perhaps the fact that Buckingham, his 'Mercury', was assassinated before Honthorst even finished his painting should have warned him that life did not follow the benign stagecraft of some allegorical masque. Instead of considering this, Charles almost immediately commissioned a still more ambitious allegory from the master of international Baroque painting, Peter Paul Rubens.

In his paintings for the ceiling of the Banqueting House in Whitehall Palace, Rubens created three swirling cosmic allegories of the reign of Charles's father James I. Rubens had the gift to send symbols flying through space with so much dash and bravura that you barely notice their absurdity. Gods and monarchs float impossibly overhead. Peer long enough into the painterly razzle dazzle and you might recognize James I commanding Minerva to join England and Scotland, Hercules beating Ignorance with a club, Reason bridling Intemperance, and Abundance defeating Avarice. Rubens knew how to speak the King's language.

On 30 January 1649 Charles I stepped out of a window of the Banqueting House onto the wooden stage built for his execution. As he waited in this great room to be beheaded he would have one

last chance to see Rubens's flowing and abundant fiction of divinely appointed monarchy. Then he knelt for the axe. It was the final chop for his Baroque arcadia.

The execution of the King was followed by the new Commonwealth's sale of his goods. It included several paintings by Artemisia, among which were noted 'Arthemisia gentelisco done by her selfe', and 'A Pintura A painteinge: by Arthemesia.'

The first was sold for £20, the second for £10. After the Restoration in 1660, one of them returned to the Royal Collection, listed in a 1687–8 inventory as Artemisia's self-portrait. But which of the pictures that Parliament sold had actually been recovered?

She moves forward with an almost violent lurch, so absorbed in her work that she doesn't care how she looks or what you think of her. The right sleeve of her green silk dress is rolled up above her elbow, as the sleeves of Judith were rolled up to slaughter Holofernes. But in her hand is a brush, not a sword. It's delicate, like the one her right hand holds in the drawing made of it in Rome. But this hand is not ladylike. It's as strong and meaty as her forearm. She is no 'gentlewoman' among artists. She's a worker. Her black hair is tied at the back and hangs loose at the front in thick, inky strands. Her face does not look at us but at a canvas we can't see. Her dark eyes gaze at it with unbreakable attention. They are just about visible to us as she faces leftward ignoring all distractions. The palette in her left hand, held by a thumb that's stuck through its hole, holds a formless smear of colours. The wall behind her is a nondescript brown. On the canvas that we can't see, her hand and eye are transforming muddy nothingness into a picture. Around her neck hangs a medal on a gold chain, a mask with empty eyes. It hangs over her pale chest and down below her breasts as she stretches her body in the grip of creative fury.

This is the painting by Artemisia Gentileschi that's still in the Royal Collection today – a masterpiece that tells her true story. It

is a depiction of her secret self and what really mattered to her. She was a painter, and only in the act of painting could she truly be free. Since she had started to paint as a teenager she had faced distractions, including violence. 'Don't paint so much, don't paint so much', Tassi had told her, throwing her paints and palette aside. This woman holds her palette and brush firmly – her thumb locked into the aperture so it can't be grabbed away. In spite of that early attack on her right to paint, in spite of the later sideshows of her life – from debts, insults and flattery to the endless quest for patronage – in spite of the detour of fame itself, here she is, and she has no thought except to paint. She sees nothing but the canvas before her. She is lost in the ecstasy of her art. She has become Painting.

On the ceiling of the Great Hall at Greenwich her father, too, portrayed Painting. His allegorical woman sits on a bank of grey – English? – clouds, almost nonchalantly working on a grisaille (that is, grey-toned) picture of Minerva. She is part of a squadron of symbolic women who gather in the misty heavens of the ceiling's nine pictures. Like Honthorst, Orazio was asked to paint a celebration of the Stuart monarchy's cultural golden age. His *Allegory of Peace Reigning over the Arts* is populated by such figures as Grammar, Arithmetic, Astronomy, Reason and Agriculture, many of them planned out using the illustrated 1603 edition of Cesare Ripa's *Iconologia*, a manual of moral symbols or 'emblems'. Yet this constellation of symbolic women is static and dull. They seem imprisoned in their skies. Orazio had left Rome because he couldn't compete in fresco painting. In London his ceiling looked becalmed compared with the pyrotechnics of Rubens that were installed in the Banqueting House by early 1636.

Artemisia's painter must be the work the Commonwealth sold as 'pintura', a misspelling of *Pittura* – Painting. She is actually more precisely based on Ripa than Orazio's version of Painting. She wears a chain with a mask, as he prescribes, and has bedraggled black hair

and intense eyebrows, as he also specifies. Even her lack of care for her clothes and 'twisted' pose are specified by Ripa. One thing she does have in common with Painting on Orazio's ceiling, however, is a green dress. Artemisia had painted allegories before, going back to her *Allegory of Inclination* in Florence. In fact the use of women as symbols was archetypally Florentine, and she would have been saturated in it at the Accademia. Charles I owned her *Allegory of Fame*. But her *Pittura* is surely a response to Orazio's allegorical ceiling, including his personification of Painting. It would be too much of a coincidence for Artemisia to leave an Allegory of Painting in London without it being a comment on Orazio's.

It is a competitive, even a dismissive response to Orazio's last work. Where his embodiments of the Arts sit lethargically, Artemisia's moves forward in energetic determination. Painting may be a woman but she is as athletic as Michelangelo frescoing the Sistine Chapel. Once more Artemisia lays claim to the hero's mantle.

We feel instinctively this is a self-portrait and that is how it has been catalogued since re-entering the Royal Collection in the later seventeenth century. Only in modern times was it recognized that it's also an allegory, in which Artemisia gives herself the attributes of Ripa's emblem. But that interpretation is not quite right. This cannot be a self-portrait in a conventional sense.

Artemisia didn't have black hair, or black eyebrows, and her hands were elegant rather than hefty. Moreover she was about 46 when she painted *Pittura*. This woman is younger. One reason the confusion has arisen is that for a long time, there were no other self-portraits with which to compare the Royal Collection picture. But the discovery of two depictions of herself done in Florence and described in Medici collections, posed as Saint Catherine and a lute player, seems to give a much clearer idea of what she looked like. Artemisia as Saint Catherine looks at us with soft eyes from a broad

face. Then again, the painting by Simon Vouet that may show her in Rome has a much narrower face.

Artemisia invested herself in paintings without necessarily being the model. She's 'there' in *Susanna in the Elders*, in *Judith and Holofernes*. She seems to be at once painter and subject of the nude Cleopatra as well as Lucretia – but what does it mean to paint yourself asleep or contemplating suicide? How was it even possible technically?

At least the self-portraits as Saint Catherine and a lute player conform to the most familiar convention of self-portraiture, for Artemisia looks at us, or rather in the mirror. Even if we can't see her paintbrush, we see that she's facing forward both to see herself and engage with us. The palm that Saint Catherine holds takes the place of Artemisia's brush. But even in these self-portrayals she's playing games. She tells stories of martyrdom and love, of a woman tortured or singing sadly to the notes of her lute.

Pittura, or *The Allegory of Painting*, is by contrast a hugely unlikely self-portrait. Rembrandt, Poussin, Van Dyck and other seventeenth-century self-portraitists boldly reinvented this genre, but none of them painted themselves looking away from the beholder. Self-portraiture is a conversation between artist and onlooker. Rembrandt holds you with his age and insight, sucking you into his agonized knowledge of life and death. Pittura, however, looks away, interested only in her canvas. She wants to vanish into her physical and mental labour. She doesn't want to know anyone is watching. Like Susanna, she shuns her beholder.

There was a precedent for this pose, as well as for the many subtle and mystifying ways Artemisia puts herself into her art. The upward-turned face of Pittura, caught in a light that hits her in the eyes, resembles the similarly upturned and illuminated face of a witness in Caravaggio's *The Betrayal of Christ*. This witness, who looks towards

the left of the scene where Christ is being seized, holds up a lantern, whose light shows us the truth. The face is Caravaggio's own and the lantern is a symbol of his truth-telling art. In Artemisia's painting, the painter holds up her right arm just as Caravaggio does, with her brush in place of his lantern. Look closely and the echoes get eerier. Not only are their faces and raised arms the same, but Artemisia clutches her brush between a powerful thumb and forefinger. We see the same view of thumb touching forefinger in Caravaggio's *Betrayal*.

This helps to explain why Pittura's hand looks meatier than her hands usually do. It is Caravaggio's hand.

Back in Rome as a child, Artemisia had been astounded by the genius of her father's friend. Now, in London as her father was dying, she remembered again the greatest, most dangerous artistic influence on her youth. In Charles I's collection it was hard to forget him. Caravaggio might have been old hat in Italy but he was a hero at the English court. His distressingly matter-of-fact painting *The Death of the Virgin*, rejected in Rome because it was said to depict a dead prostitute and anyway had none of the conventional assurances of the Virgin's immediate assumption into Paradise, now hung in one of Charles's palaces.

In her *Allegory of Painting*, Artemisia sets out her stall to Charles as the most radical follower of Caravaggio, an artist who truly shares his extreme eye for the real. Indeed, she claims to be him. *The Allegory of Painting* merges their identities in one furious female artist.

Artemisia has not pedantically replaced her own tawny hair with the black hair specified by Ripa – after all, she didn't include the blindfold the iconologist stated Painting should have – but singles it out because it also makes this an image of Caravaggio as a woman. His black hair and eyebrows merge with those of Painting because, for her, he epitomizes Painting and always has.

Pittura faces into the light in the same pose as Caravaggio in the *Betrayal*, holding up her brush as he holds up his lantern, with his death-black hair. Yet she also has Artemisia's attributes. The loose hair hanging around her face first appeared in Orazio's fresco portrait of Artemisia as a teenager on the Quirinal. In the print of her published in Venice and a medal from the same years she has similarly loose and wild hair.

The Allegory of Painting is not a self-portrait – and yet it is. You could call it idealized, except that it is so rawly alive. Artemisia sells herself to King Charles and Queen Henrietta as the real thing – literally, a female Caravaggio. But there is an emotional possession going on here that makes this great painting so much more than a promotional self-portrait. What it has most mysteriously in common with Caravaggio is that they look away from their spectators, in this case the King and Queen, into the world they have painted into being. Artemisia is lost in her art as Caravaggio was lost when he painted himself as the sleeping Saint Francis. If this is not a self-portrait it is because when she paints, she is another person.

Artemisia told the Duke of Modena in December 1639 that she was honoured and graciously treated at the English court. Queen Henrietta Maria was her 'lady mistress' and the King took an interest in her, too. The number of her works in the King's collection before the Civil War confirms that status. She was holding her own not only against her father but the King's favourite Anthony van Dyck. Yet she was still more interested in Italian patrons, hence the letter to Modena, with which she sent a painting. When she went back south, however, it would not be to a secure court position.

At least she survived London. It wasn't only Orazio who was buried there. Van Dyck died in England in December 1641. He succumbed to illness with magnificent timing, for the entire edifice of the Stuart court was crumbling. In January 1642 Charles fled London

with his family for a safer base in the north. On 23 October that year the first big battle of the English Civil War took place at Edgehill. It's not certain when exactly Artemisia left England to return to Naples. It seems reasonable to suppose she left when the Queen's House was closed up and the court vanished in early 1642.

There's something very English-looking about the architecture in a painting of Bathsheba that Artemisia worked on in the early 1640s. The story of Bathsheba was another Biblical tale of nudity and voyeurism that she painted several times in her later years. This young woman was bathing outdoors when she was seen by King David. He longed for her, and what King David wanted he got. All the versions Artemisia painted stress Bathsheba's relationship with her maids. In a painting done between 1636 and 1637 she shows a very lifelike servant with her sleeves rolled up kneeling with a silver footbath, while two finely dressed attendants help Bathsheba with her hair and jewellery. The same division of labour appears in the 1640–1 version, in that English-looking palace garden. This time the servant with the rolled-up sleeves is carrying a bucket to refill the silver bath. But in a signed picture of Bathsheba that Artemisia painted between 1645 and 1650, the hierarchy is breaking down. While a completely naked Bathsheba raises her arm to be washed, the servant figure has now joined the main group and is pointing out the distant figure of David to one of the lady attendants who has started to take off her own golden dress.

Artemisia lived in a supposedly ordered and immobile world where kings and dukes ruled polities, the Pope ruled the Catholic flock, fathers and husbands ruled families, and householders ruled servants. But a few years after escaping an England on the edge of an internecine war that would end with a decapitated king and the establishment of a republic, Artemisia lived through a furious popular uprising that turned Naples into a carnival kingdom of

savagery. It was as if in her *Judith and Holofernes* she had foreseen these ferocious rebellions that cut off heads and sent blood spurting.

In a painting by Domenico Gargiulo of the popular rising that overwhelmed Naples in 1647, the severed head of a Spaniard is held aloft on a pikestaff while a yelling, banner-waving crowd are slaughtering nobles and priests and dragging their naked bodies. In a nicely observed detail, some laundry still hangs out from the tall tenements behind the bloody massacre. A man on a podium wearing a red cap addresses the frenzied crowd.

The man speaking to the people is Tommaso Aniello, nicknamed Masaniello, a fisherman from Amalfi who led the revolt after the Spanish regime tried to tax fruit – the last straw in a series of extra impositions as the Habsburgs milked their empire to pay for the Thirty Years' War in their German lands. Masaniello has just ordered the killing of Don Giuseppe Carafa, a Neapolitan aristocrat. It's Carafa's head on the spike.

Where was Artemisia when aristocratic heads were rolling?

The painter Giovanni Lanfranco, who was working in Naples, had to stay away during the tumult while one of his works in the city was destroyed by the vengeful crowd. Ribera, meanwhile, took refuge with the court – he was, after all, both Spanish and rich – and painted an equestrian portrait of Don John of Austria, who was sent by Philip IV to crush the revolt.

Artemisia's sympathies may have been more complicated. An artist who worked closely with her in these years, Onofrio Palumbo, painted an up-close portrait of Masaniello in his red cap. For Masaniello's supporters were not just the desperate poor. Although he himself was quickly murdered by a band of nobles after his speeches apparently became irrational and egomaniacal, Don John's heavy-handed military tactics provoked a second revolt with a broader social base that established a short-lived Neapolitan Republic. Palumbo

could have been one of its supporters. Another work by him, *San Gennaro Interceding for Naples*, in Santissima Trinità dei Pellegrini, might also be seen as republican in its loving, lofty view of the entire city spread out on the bay under Gennaro's protection.

An early eighteenth-century inventory calls Palumbo, to whom it credits a near-nude Mary Magdalene, 'a disciple of Artemisia Gentileschi'. Banking records bear this out. A bill of exchange dated 3 January 1653 shows her paying him as her assistant for work on a *Susanna*. Another financial record dated 31 January 1654 shows them collaborating again and receiving an advance for three paintings 'of a quality and goodness conforming to the obligations undertaken by the said Artemisia' and which 'the said Onofrio has to finish and deliver within a month and a half'.

Whether or not Artemisia shared Palumbo's sympathy for Masaniello's revolt, she painted two new versions of *Judith and Her Maidservant* in the late 1640s, whose deep shadows and rough expressionism suggest a time of troubles. They both repeat the scene she composed in Rome two decades earlier, but where that is warmly coloured like a work by Honthorst or even Rubens, these are bleaker, more desperate. The light of the candle is weak. The anxious looks of the two women as they get ready to escape with Holofernes' head imply panic in the dark tent. Its draperies are no longer red but funereal black.

Artemisia's correspondence with the Sicilian art collector Don Antonio Ruffo in this period reveals a fraught life, caught between her ambition for greatness – she claims to have the spirit of Caesar in a woman's soul – and her need for cash. Ruffo was a remarkable art lover. From his palace in Messina he not only commissioned what seem from their descriptions (for none are known to exist) to have been spectacular works by Artemisia, but also, much further afield, paid Rembrandt to paint one of his supreme masterpieces, *Aristotle*

Contemplating the Bust of Homer. That was sent from Amsterdam to Sicily in 1653. Artemisia's dealings with Don Ruffo date from a few years earlier but once again, as in the Medici collection, as among Charles I's pictures, she was working at the very heart of the Western canon.

But Artemisia needed money. Writing to Don Ruffo on 30 January 1649 she mentions the high prices she used to command in Florence, Venice and Rome, 'and in Naples too when there was more cash...'

She may have been referring to the economic aftermath of the 1647 rebellion. What she wanted from Don Ruffo was not vague esteem but the good prices she used to get in the old days. They seemed forthcoming: in March 1649 she duly acknowledged a payment of 100 ducats. Unfortunately it wasn't enough. In June she pleaded for another 50 ducats so she could afford to finish a picture for him – and again got it. By the autumn of 1649, however, Don Ruffo wanted to reduce her fee and was accusing her of doing less work for him than for his nephew Don Fabrizio, who was a prior in Naples. Artemisia explained that she had had to make a special deal with Don Fabrizio because of 'extreme necessity' – in other words, she needed money fast. The wrangling continued, with Artemisia insisting on 13 November that she couldn't accept less than 400 ducats for the paintings she'd promised, and she needed a deposit.

Artemisia then claims in her letter of 13 March 1649 that she's broke because she has just married off a daughter to a Knight of the Order of St James, and it's ruined her. If this is Prudentia, who would by now have been in her thirties, what happened to the other marriage? If she was widowed, in theory she should not have needed Artemisia to provide a dowry. Maybe Artemisia had another daughter?

Equally curious is Artemisia's connection with the Knights of the Order of St James, meaning the Spanish knightly order of Santiago.

To be a Knight of Santiago was a high honour conferring serious status; Velázquez wears the red sword-shaped cross of the order in his painting *Las Meninas*, proudly displaying this lofty rank. It seems Artemisia still had impressive contacts at the Spanish court in Naples.

Another expense that bugged her was paying models. Her paintings for Don Ruffo were mythic scenes full of nudes. Fittingly enough she sent these Mediterranean idylls, including a *Bath of Diana*, by sea from Naples to Sicily. But she had to hire women to pose naked – presumably from among the ranks of the sex workers of Naples – and they wanted paying: 'Believe me, my lord Don Antonio, the expenses are intolerable because there's barely a good one out of fifty who get undressed.'

They steal and they're petty; they would try the patience of Job. The Artemisia we meet in these final letters is still the rough-and-ready character who once abused and insulted Margherita. She's no smooth courtier, no modest gentlewoman. She's a Roman woman, she warns Don Ruffo – she doesn't haggle like a Neapolitan.

Artemisia is blunt about money, and even vulgar or honest enough to reveal her desperation. Through it all she insists on the merit of her work and her right to respect as an artist. Outraged that a friend whom Don Ruffo has encouraged to commission her wants to see drawings first, she explains how she was conned by a client, a bishop, who got her to provide designs for a scene of Purgatory and then got another, cheaper painter to execute it, declaring, 'if I was a man (*che fusse homo*) I don't believe that would have happened...'

If I was a man. Artemisia was still battling to be accepted in the man's world of painting. The final enigma of her letters to Don Ruffo concerns the paintings she sent him. One was a picture of Galatea, daughter of the god of the sea. Raphael's 1514 fresco of Galatea riding across the sea on her shell-chariot, pulled by dolphins and

surrounded by a court of tritons and nymphs, created a soft splashy marine iconography of pleasure. In the mid-seventeenth century this imagery of flesh and water was being translated into a superabundant living art by Bernini's Roman delights the Triton Fountain and the Four Rivers Fountain. What became of Artemisia's contribution to this art of watery celebration?

Her *Galatea* was damaged at sea on its way to Sicily, but apparently not too severely. It is described in an inventory of Don Ruffo's collection as follows: 'Galatea on a crab shell pulled by two dolphins and accompanied by 5 tritons.'

This description closely corresponds with two paintings attributed today to the Neapolitan painter Bernardo Cavallino. In fact, each of them has a single difference from it – and they're complementary differences, like the joints of two pieces meant to fit together. One, known as the *Triumph of Anfitrite*, shows a naked woman riding a huge crab shell, pulled by two dolphins. But she's flanked by four young men posing as tritons, not five. Another painting, sold in 2007 as *The Triumph of Galatea* by Cavallino, has the requisite five tritons – but Galatea rides a conch shell.

It's inconceivable that the two paintings are not in some way connected with Artemisia's work. It has been suggested she collaborated with Cavallino on the painting of Anfitrite. Both could be partly copied from her design for Don Ruffo. Perhaps they should be labelled 'after Artemisia Gentileschi', for as she told her Sicilian patron, 'when the invention has been made, and established with lights and darks, and its planes are set, all the rest is easy...'

It would be nice to end on a Mediterranean idyll and watch Artemisia float away across blue seas. In her last letter to Don Ruffo on 1 January 1651 she says she has been seriously ill. She asks for money yet again, so she can get treatment. And then silence. He may not have replied.

Art historian Giuseppe Porzio has discovered that from May 1651 Artemisia was renting an apartment in a communal block that gave her limited private space while other rooms were shared with fellow tenants. It certainly doesn't sound grand. Her landlady was Vittoria Corenzio, daughter of Belisario Corenzio, who had conspired with Ribera to hound rival artists out of Naples. So crime paid.

Artemisia's last known incontrovertible paintings, both signed and dated, take a less halcyon view of nudity. In these final works she once again returns to the scene of the crime – Susanna's bath. Revisiting this oldest of her themes in 1649, she portrays a young woman who thrusts her head away from the looming Elders, twists her body and raises her arms as if not just to shoo them away but fight them off. She is the most physically agitated of Artemisia's Susannas, consumed by a paroxysm of horror at her persecutors that's all the more expressive because they don't creep forward but stand with statuesque stillness. In her version of 1652, they look at her quizzically as she rears back from them. It is like a conversation among philosophers. Why is she so upset?

In both paintings the Elders have aged. One is still younger than his companion but he's well on in life. In the 1652 version he is a grey-haired man of substance who looks wryly amused by Susanna's shock.

This scene feels as if it is playing out in eternity. Tassi had died in 1644. In Dante's *Inferno* the poet visits Hell and meets the dead; so in Artemisia's last paintings, the Elders are impassive reprobates eternally menacing an ever-changing parade of Susannas. After all this time, the filthy old ghosts still won't admit they've done anything wrong.

Naples is a good place to die. The ranks of skeletons in its underground sepulchres, the skulls carved in cloisters and, most movingly of all, that anonymous body being buried out of charity in

Caravaggio's *Seven Works of Mercy*, all testify to the concentration of Baroque minds on mortality. Artemisia would certainly have wanted the last rites properly performed. She makes an anxious protestation to Don Ruffo: 'and I know through my errors offence will be given to my Lord God, and I fear I will no longer be infused with the grace of God...'

The last trace of her alive is a payment in August 1654 – a token amount against an overdue tax bill. Then she really does fall silent. She probably died before the great plague that ravaged Naples in 1656, wiping out 50 percent of its people. Her fellow artists Onofrio Palumbo, Massimo Stanzione and Bernardo Cavallino may all have died in this apocalypse.

The painter Salvator Rosa survived, but lost many of those closest to him. His painting *Human Frailty*, done in the immediate wake of the plague that shattered his family, shows a baby signing a contract with Death. If Artemisia predeceased the epidemic, at least she was spared such horrors.

Artemisia's grave has vanished but there was reportedly a slab in the now-destroyed church of San Giovanni dei Fiorentini in Naples that simply read: HEIC ARTEMISIA.

No Gentileschi, no Lomi, no Stiattesi. Just Artemisia, herself alone.

Further Reading

Sheila Barker, 'The Entrepreneurship of a Woman in Seventeenth-Century Florence', in Sheila Barker (ed.), *Artemisia Gentileschi in a Changing Light* (Belgium: Turnhout, 2017)

——, 'The First Biography of Artemisia Gentileschi', *Mitteilungen des Kunsthistorischen Institutes in Florenz*, 60.3 (2018), pp. 404–35

——, 'A New Document Concerning Artemisia Gentileschi's Marriage', *The Burlington Magazine*, 156 (December 2014), pp. 803–4

R.W. Bissell, 'Artemisia Gentileschi – A New Documented Chronology', *Art Bulletin*, 50.2, (1968), pp. 152–68

Jerry Brotton, *The Sale of the Late King's Goods : Charles I and His Art Collection* (London: Macmillan, 2006)

Peter Burke, *Popular Culture in Early Modern Europe* (Middlesex: Temple Smith, 1978)

——, *The Historical Anthropology of Early Modern Italy* (Cambridge: Cambridge University Press, 2005)

Keith Christiansen and Judith Walker Mann, *Orazio and Artemisia Gentileschi* (New York: Metropolitan Museum of Art, 2001)

Elizabeth S.Cohen, 'Seen and known: prostitutes in the cityscape of late sixteenth-century Rome', *Renaissance Studies*, 12.3 (September 1998), pp. 392-409

——, 'The Trials of Artemisia Gentileschi: A Rape as History', *The Sixteenth Century Journal*, 31.1 (Spring 2000), pp. 45–75

Patrizia Costa, 'Artemisia Gentileschi in Venice', *Source: Notes in the History of Art*, Vol.19, No.3 (Spring 2000), pp. 28–36

Elizabeth Cropper, 'New Documents for Artemisia's Life in Florence', *The Burlington Magazine*, 135 (1993), pp. 760–61

Gabriele Finaldi (ed.), *Orazio Gentileschi at the Court of Charles I* (London, Bilbao, Madrid: Museo de Bellas Artes de Bilbao, 1999)

Gabriele Finaldi and Jeremy Wood, 'Orazio Gentileschi at the Court of Charles I', in Christiansen and Mann (2001)

——, 'Orazio Gentileschi at the Court of Charles I: Six Documents', in Christiansen and Mann (2001)

Adelin Charles Fiorato and Francesco Solinas (ed.), *Artemisia Gentileschi: Carteggio/ Correspondance* (Paris: Les Belles Lettres, 2016)

David Freedberg, *The Eye of the Lynx : Galileo, His Friends and the Beginning of Natural History* (Chicago: University of Chicago Press 2002)

Michael Fried, *The Moment of Caravaggio* (Princeton University Press, 2010)

Mary D. Garrard, *Artemisia Gentileschi: The Image of the Female Hero in Italian Baroque Art* (Princeton University Press, 1989)

Andrew Graham-Dixon, *Caravaggio : A Life Sacred and Profane* (London: Penguin, 2010)

John R. Hale, *Florence and the Medici: The Pattern of Control* (London: Thames and Hudson, 1978)

Belinda Jack, *Beatrice's Spell: The Enduring Legend of Beatrice Cenci* (London: Chatto and Windus, 2004)

Alexandra Lapierre, *Artemisia* (France: Éditions Robert Laffont, 1998; translation by Liz Heron, London: Chatto & Windus, 2000)

Jesse Locker, *Artemisia Gentileschi: The Language of Painting* (Yale University Press, 2015)

Jesse Locker, '"Con Pennello di Luce": Neapolitan Verses in Praise of Artemisia Gentileschi', *Studi Secenteschi*, 48 (2007), pp. 243–62

Oliver Millar (ed) *Inventories of the Commonwealth Sale* (*Walpole Society Vol. 43*, 1970–72)

Eva Menzio (ed.), *Artemisia Gentileschi: Lettere/Atti di un Processo Per Stupro* (Milan: Abscondita, 2004)

J.C. Porter, *Baroque Naples: A Documentary History, 1600-1800* (New York: Ithaca Press, 2008)

Giuseppe Porzio, *Artemisia Gentileschi: Cleopatra* (Paris: Galerie Sarti, 2014)

Francesco Solinas, 'Ritorno a Roma', in *Artemisia Gentileschi: Storia di una passione* (Milan: 24 Ore Cultura, 2011)

Francesco Solinas, with Michele Nicolaci and Yuri Primarosa (ed.), *Lettere di Artemisia* (Rome: De Luca Editori d'Arte, 2011)

Nicola Spinosa, *Ritorno al Barocco* (Naples: arte'm, 2009)

Maurizia Tazartes, 'La vita e l'arte', in Pietrangelo Buttafuoco, *Artemisia Gentileschi* (Milan: Skira, 2016)

David Topper and Cynthia Gillis, 'Trajectories of Blood: Artemisia Gentileschi and Galileo's Parabolic Path', *Woman's Art Journal*, 17.1 (1996), pp. 10–13

Abraham van Doort, *Inventory for Charles I, transcribed by Oliver Millar* (*Walpole Society Vol. 37*, 1958-60)

Margot and Rudolf Wittkower, *Born Under Saturn* (New York: New York Review of Books, 2007)

Rudolf Wittkower, *Art and Architecture In Italy 1600–1750* (London: Penguin Books, 1958; revised by Joseph Connors and Jennifer Montagu, Yale University Press, 1999)

David Wootton, *Galileo : Watcher of the Skies* (New Haven: Yale University Press, 2010)

Natalie Zemon Davis, 'Women on Top', in *Culture and Society in Early Modern France* (Standford: Stanford University Press, 1975)

Stefano Zuffi ed., *Vite di Caravaggio: Testimonianze e Documenti* (Abscondita: Milan, 2017)

Index

All paintings are by Artemisia Gentileschi unless otherwise indicated

Index

Index

Index

Index

Acknowledgements

I'd like to thank Laurence King for suggesting a book on Artemisia Gentileschi and Donald Dinwiddie for ensuring it happened, John Parton and Marc Valli for asking me to write for this series of short fast *Lives of the Artists*, and everyone else at Laurence King publishing who has contributed to the book's production. My fascination with this artist has been shared with Artemisia enthusiasts from Breach Theatre to London's National Gallery, among whose staff I'd like to thank Tracy Jones for making it possible to visit Artemisia's Self-Portrait at HMP Send prison and Letizia Treves for a highly enlightening preview of the NG's Artemisia exhibition. *The Guardian* has generously published pieces by me on both Artemisia and Caravaggio that deepened my addiction to their art.

Credits

(numbered in order of appearance)

1 Artemisia Gentileschi, *Susanna and the Elders*, c. 1610, Schloss Weissenstein, Pommersfelden. Germany. Bridgeman Images. 2 Michelangelo Merisi da Caravaggio, *Judith Beheading Holofernes*, c. 1599, Palazzo Barberini, Rome, Italy. © Luisa Ricciarini/Bridgeman Images. 3 Orazio Gentileschi, *David and Goliath*, c. 1605–1607, National Gallery of Ireland, Dublin, Ireland. Peter Horree/Alamy. 4 Artemisia Gentileschi, *Judith Beheading Holofernes*, c. 1612–13, Capodimonte Museum, Naples, Italy. Painting/Alamy. 5 Artemisia Gentileschi, *Judith Beheading Holofernes*, c. 1620, Uffizi Gallery, Florence, Italy. Painting/Alamy. 6 Artemisia Gentileschi, *Judith and Her Servant*, c. 1616–1618, Pitti Palace, Florence, Italy. Wikimedia_Hohum_CC. 7 Artemisia Gentileschi, *Lucretia*, c. 1621, Private Collection, Italy. Art Collection 2/Alamy. 8 Artemisia Gentileschi, *Jael and Sisera*, 1620, Museum of Fine Arts, Budapest, Hungary. GL Archive/Alamy. 9 Artemisia Gentileschi, *Cleopatra*, c. 1613, Amedeo Morandotti Collection, Milan, Italy. The Picture Art Collection/Alamy. 10 Artemisia Gentileschi, *Self-Portrait as St. Catherine of Alexandria*, c. 1615–1617, National Gallery, London, United Kingdom. Abbus Acastra/Alamy. 11 Artemisia Gentileschi, *Allegory of Inclination*, 1615–1616, Casa Buonarroti, Florence, Italy. Wikimedia_Sailko_CC. 12 Artemisia Gentileschi, *Mary Magdalene*, c. 1617–1619, Pitti Palace, Florence, Italy. GL Archive/Alamy. 13 Artemisia Gentileschi, *Susanna and the Elders*, 1622, Burghley Collection, Burghley House, Peterborough, United Kingdom. Historic Images/Alamy. 14 Pierre Dumonstier II, *Right Hand of Artemisia Gentileschi*, 1625, British Museum, London, United Kingdom. © The British Museum/Trustees of the British Museum. 15 Artemisia Gentileschi, *Corisca and the Satyr*, c. 1633–1634, Private Collection. Art Collection/Alamy. 16 Artemisia Gentileschi, *The Birth of John the Baptist*, c. 1635, Prado Museum, Madrid, Spain. Heritage Image Partnership Ltd/Alamy. 17 Artemisia Gentileschi, *Saint Januarius in the Amphitheatre at Pozzuoli*, 1636–1637, Capodimonte Museum, Naples, Italy. Wikimedia_Never covered_CC. 18 Artemisia Gentileschi, *The Allegory of Painting (La Pittura)*, c. 1638–1639, Royal Collection, Hampton Court, United Kingdom. The Picture Art Collection/Alamy. 19 Artemisia Gentileschi, *Susanna and the Elders*, 1649, Moravian Gallery, Brno, Czech Republic. Wikimedia_Trzesacz_CC. 20 Artemisia Gentileschi, *Judith and Her Servant*, c. 1645–1650, Capodimonte Museum, Naples, Italy. Heritage Image Partnership Ltd /Alamy.